IMAGES
of America
NEWARK

To Anthony,
We've loved having you
stay here with us for
soccer camp! Keep
in touch and hope
to see you next
summer!!

Love,
Lori, Kelsey and Ephram

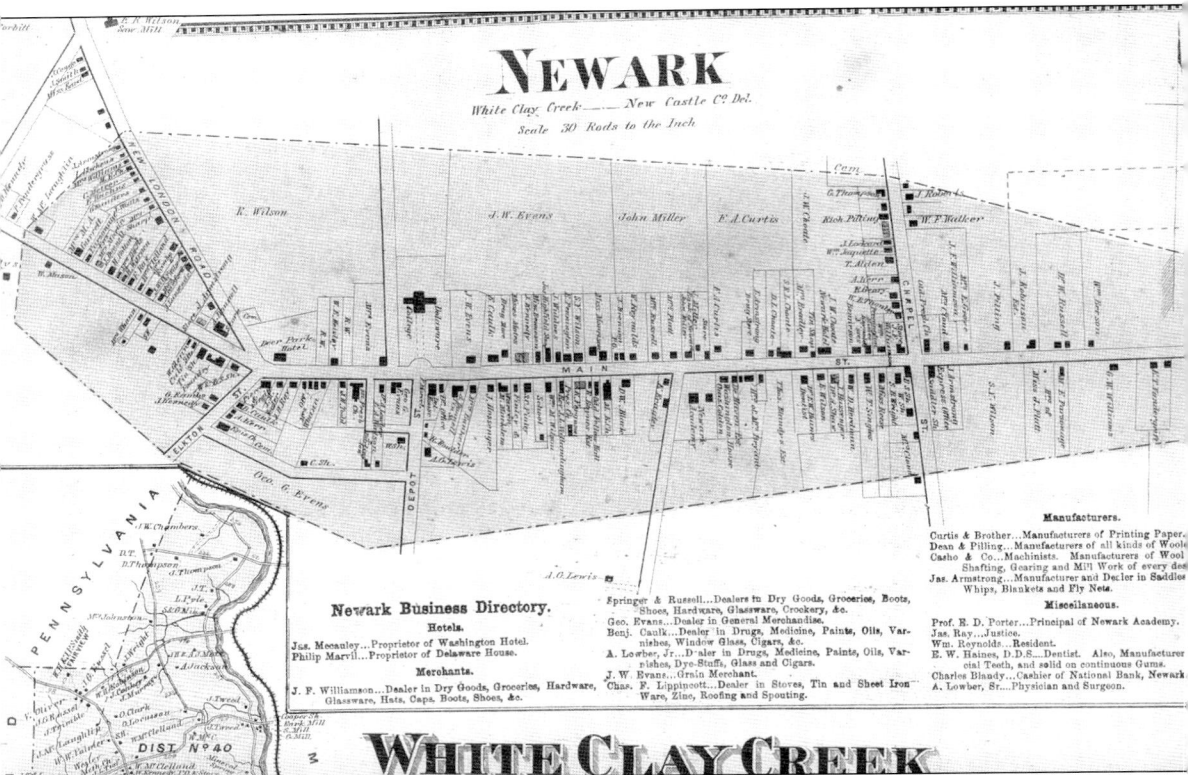

In 1868, D. G. Beers published his *Atlas of the State of Delaware*. This volume included maps of each of Delaware's hundreds as well as major cities and towns. This map of Newark illustrates the city's unique, coffin-shaped boundaries as they existed at the time. The map also lists property owners and their locations, as well as a selected business directory. (Author's collection.)

ON THE COVER: The Green Mansion, located at 94 East Main Street, was constructed by David Caskey in 1882. Named as such because of the green granite blocks used on its facade, it became the home and office of Dr. G. Burton Pearson Sr. in 1918. Pearson is pictured with his wife, Estelle Cochran Pearson, on the porch. (Courtesy of Special Collections, University of Delaware Library, Newark, Delaware.)

IMAGES
of America
NEWARK

Theresa Hessey

Copyright © 2007 by Theresa Hessey
ISBN 978-0-7385-5284-2

Published by Arcadia Publishing
Charleston SC, Chicago IL, Portsmouth NH, San Francisco CA

Printed in the United States of America

Library of Congress Catalog Card Number: 2007925545

For all general information contact Arcadia Publishing at:
Telephone 843-853-2070
Fax 843-853-0044
E-mail sales@arcadiapublishing.com
For customer service and orders:
Toll-Free 1-888-313-2665

Visit us on the Internet at www.arcadiapublishing.com

Dedicated to the memory of my father, Robert D. Hessey

Contents

Acknowledgments		6
Introduction		7
1.	Main Street and Vicinity	9
2.	Historic Homes and Significant Architecture	31
3.	University of Delaware	55
4.	Residents and Businesses	87
5.	Transportation and Industry	105
6.	Religion and Community	117
Bibliography		127

Acknowledgments

As with any work of this nature, this book could not have been completed without the assistance and support of many individuals. The Special Collections department at the University of Delaware's Morris Library houses an extensive collection of Newark material. I am particularly grateful to Rebecca Johnson Melvin, Tim Murray, Anita Wellner, and other Special Collections staff for unfailing encouragement and professional assistance above and beyond the call of duty. For technical assistance and Thursday night visits, I must thank Melissa McDade. Thanks also go to Peggy Tatnall and Michele Glasburgh for research and editorial assistance. Richard L. Dayton generously allowed me to peruse the collection he has amassed over many years and granted me permission to include many of his personal photographs. His assistance and insight are greatly appreciated. Other Newark residents contributed both photographs and family stories, including Robert Cronin, Delaware Auto Parts, Paul Goodchild, the Herman family, Frank C. Mayer Jr., and Sylvia Dale Williamson.

Thanks also go to my family—Denise Attarian, Pat Hessey, and Patty Landreth—for providing leads, contacting friends and acquaintances, taking over family and other responsibilities, and forgiving my absentmindedness. Thank you for your unconditional support and everything you do without question. It's a debt that I can never repay. Finally, to my daughter Riley Hessey, who came into the world toward the end of this project, thanks for reminding me to enjoy the simple things.

INTRODUCTION

Newark, Delaware, located at a crossroads of two Lenni-Lenape trails, grew into a small village when English, Welsh, and Scottish immigrants began settling there in the early 18th century. Originally named New Ark, the town gradually expanded its boundaries to include farms, churches, mills, brickyards, and other industries. Seeking official recognition from England, six residents—James McMechan, Reynold Howell, William McCrea, William Eynon, William Armstrong, and David Wilkin—petitioned King George II, formally requesting that the village be chartered as a city. On April 13, 1758, the charter for the city of Newark was granted.

The town grew quickly, partially because of the Newark Academy. Francis Alison, a Presbyterian minister, founded the New London Academy in New London, Pennsylvania, in 1741. Alison later accepted a position with the Presbyterian Church in Philadelphia, and Andrew McDowell assumed control of the school. It was under McDowell's tenure that the academy was moved to Newark in 1761. The community encouraged the expansion of the school, which grew into Newark College, then Delaware College, and finally, in 1921, the University of Delaware. It was a men's college for most of its history, although coeducation was tried unsuccessfully during the late 19th century. In 1914, a separate Women's College was opened nearby, and eventually the two colleges merged under the name "University of Delaware." Coeducation was implemented in small measures beginning in the late 1920s, when summer classes were offered to both sexes. However, full coeducation was not achieved until 1945, when it was made permanent by the board of trustees.

The residents of Newark provided the university with land to expand the campus. The 19-acre tract that comprised the Women's College was purchased from the Wollaston family. Many residents opened their homes to students and provided lodging and other services in addition to selling parcels of land to the university. Prominent citizens such as George Gillespie Evans and his son, Charles B. Evans; Thomas Blandy; and Joseph Hossinger served on the board of trustees and in other capacities. Over time, many of the residential homes that once lined Main Street and the surrounding area were purchased by the university and renovated to serve the university community as office space. Today the student population plays a large role in the economic stability of the town.

Religion was also a significant factor in the growth of Newark. After years of worship in congregants' homes, numerous churches were built on the outskirts of town to be more easily accessible to the surrounding gentleman farmers and their families. Welsh Tract Baptist Church was built in 1703 three miles south of the town. Head of Christiana Presbyterian Church, founded as early as 1706, was located just to the west of the city and White Clay Creek Presbyterian Church, founded in 1721, to the northeast. Beginning in the early 19th century, other churches were constructed near or on Main Street. First Presbyterian was built around 1843, while Newark United Methodist Church was founded in 1811 and constructed a church on Main Street in 1852. The first Roman Catholic church, originally called St. Patrick's and now known as St. John–Holy Angels, was organized in 1850 and met in the homes of parishioners until 1870, when the Village

Presbyterian Church at the southeast corner of Main and Chapel Streets was purchased by Charles Murphey, donated to the diocese, and renovated. All of these churches are still active today.

As Newark expanded, businesses and homes began to appear along Main Street, with larger industries situated on the outskirts of town. Residents organized two annual fairs, one in April and one in October, and a weekly market was opened every Thursday near the academy lawn. The Dean Woolen Mills began operation in 1845, and Samuel Meeter opened a paper mill on White Clay Creek to the north of town around 1804. George Curtis and Solomon Minot Curtis purchased Meeter's mill in 1848 and founded the Curtis Paper Company. The American Hard Fibre Company was organized in 1894 and later became part of the National Vulcanized Fibre Company, while the Continental Diamond Fibre Company was founded in 1906. The success of these companies led Newark to be called the "Fibre Capital of the World."

Residents also formed a variety of civic organizations. Freemasons organized in the area as early as 1789 and after 1805 became Hiram Lodge No. 3; members included James Ray, Samuel Donnell, and John Evans. An order of Odd Fellows was organized in 1847, followed by the Knights of Pythias in 1868 and the Newark Grange in 1874. As early as 1867, Newark had a town bailiff, and a jail was constructed in 1873. The Aetna Hose, Hook, and Ladder Company was founded in 1889 and continues to operate as a volunteer fire company.

In 1837, the Philadelphia, Wilmington, and Baltimore Railroad laid tracks almost a mile to the south of town, making downtown Newark accessible to a large number of travelers and students. Later in the century, the Baltimore and Ohio Railroad also established service through the town. A post office had been founded very early and was originally housed in Alexander McBeath's home on Main Street. In 1855, the National Bank of Newark was established.

Many of the town's residents were gentleman farmers, enabling them to play an active role in Newark's businesses and organizations. James Hossinger was president of the National Bank of Newark and owner of a large and prosperous farm. He also served as treasurer for several groups, including the board of trustees of the Academy of Newark; Aetna Hose, Hook, and Ladder Company; and the Newark Real Estate Company. As the town expanded, many of the streets were named for these prominent, civic-minded men, such as Lewis Avenue, Ray Street, Haines Street, and Wollaston Avenue.

Over the years, Newark has adapted to economic changes, and the town continues to prosper. Many of the industries that once thrived here are no longer in operation, most notably the woolen and paper mills that disappeared long ago. More recently, other industries dominated the local landscape, but announcements of the imminent closure of the Avon and Chrysler plants indicate a further shift in the local economy. Main Street is now the retail hub of Newark, and the University of Delaware has become the prominent source of income for the city. It is the spirit of cooperation between the town and the university that allows Newark to remain a vibrant community.

One
Main Street and Vicinity

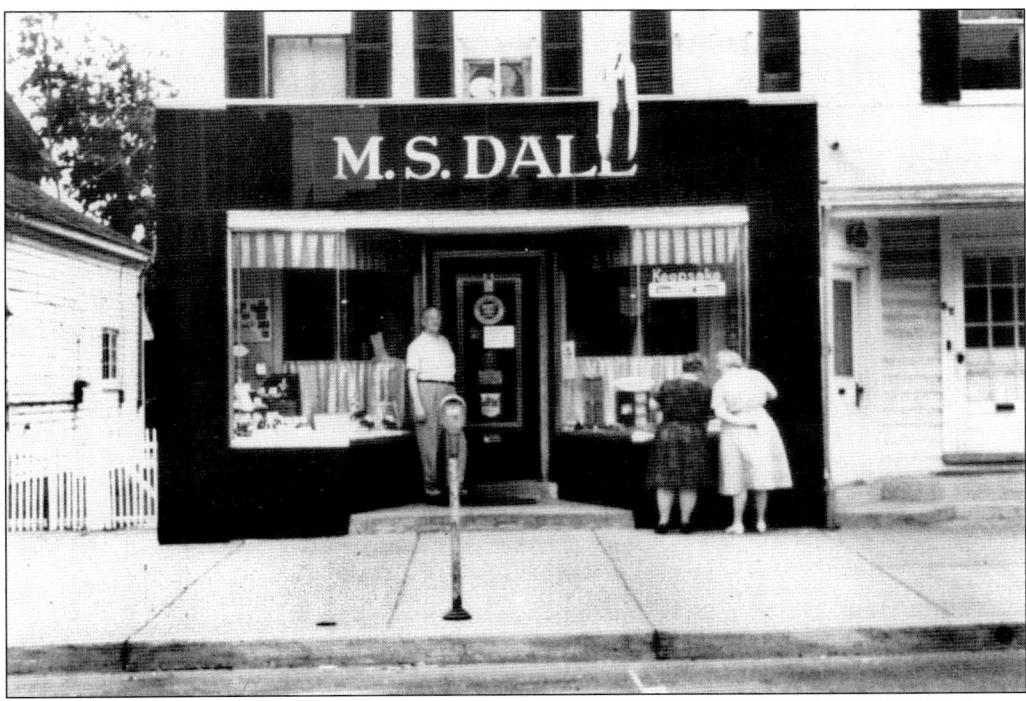

The jewelry shop of M. S. Dale was located at 59 East Main Street. Opened in 1933 by Mervin Dale, the shop operated until the late 1970s. Like many businesses on Main Street, the lower floor held a retail shop and work area, while the upper floors served as the family residence. (Courtesy of Sylvia Dale Williamson.)

Mervin and Edith Dale were married in July 1934. Although both were originally from Pennsylvania, Mervin moved to Newark to assist a friend who operated a jewelry store near the city, and in 1933, he opened his own store on Main Street. The Dales worked together in the store and raised their family above the business. (Courtesy of Sylvia Dale Williamson.)

Many stores along Main Street were family businesses. As a consequence, most families lived either behind or above the store. In this photograph, taken sometime in the 1960s, Mervin Dale's father, John, is holding his granddaughter Barbara in the family's backyard, located behind Dale Jewelers on Main Street. (Courtesy of Sylvia Dale Williamson.)

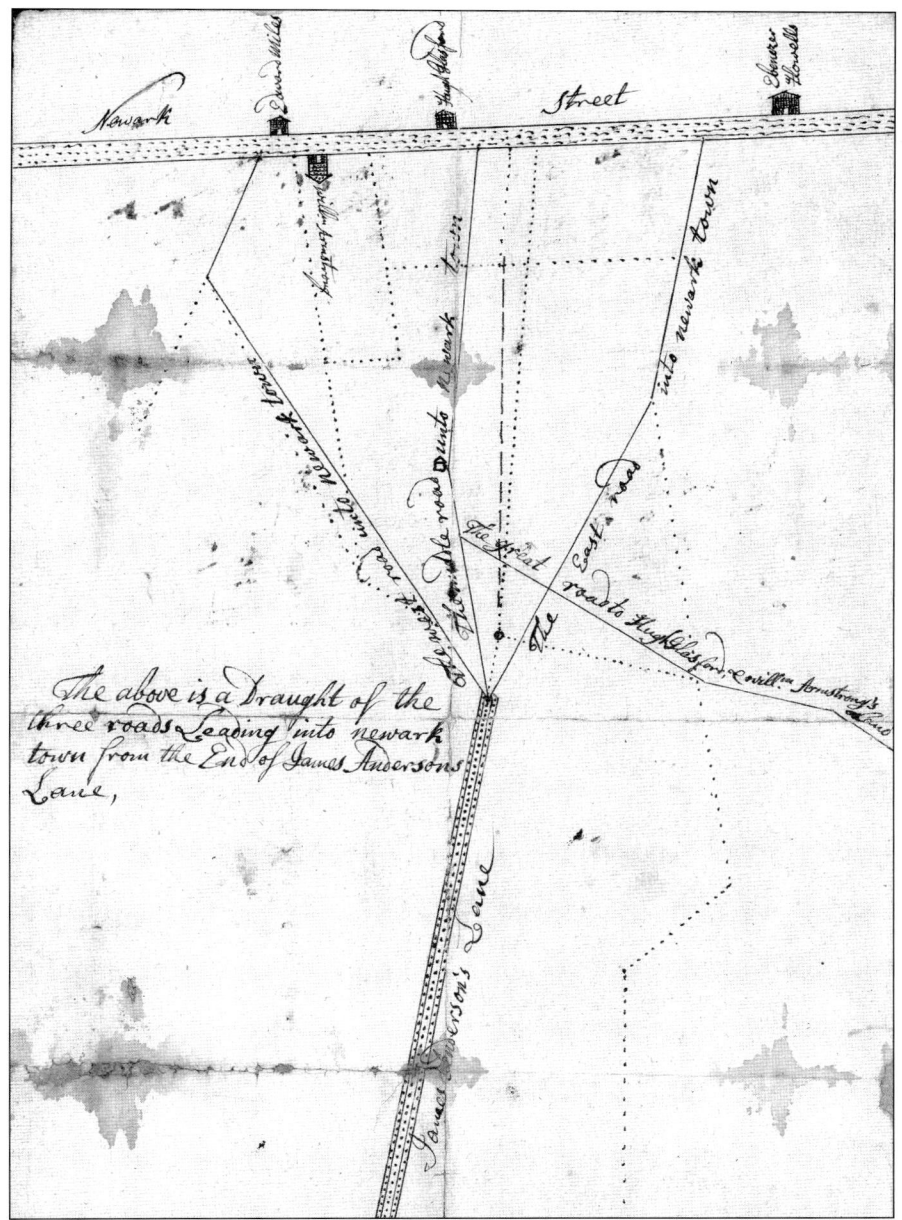

Possibly the oldest known map of Newark, this hand-drawn map is dated 1736 and depicts three roads leading into town from the end of James Anderson's Lane to the south. It is believed that Anderson's Lane ran the same course as present-day Academy Street. Anderson's Lane is also listed as a boundary of the town in the charter presented to King George II in 1758. The roads are noted as the West Road, the Middle Road, and the East Road. It is significant to note that by this time, the residents of Newark had already established a central district, and Main Street was originally known as Newark Street. The map also depicts the homes of William Armstrong, Edward Miles, Hugh Glasford, and Ebenezer Howell along Newark Street. It is known that Howell operated the Three Hearts Tavern, an inn and tavern located in the Exchange Building, as early as 1739. (Courtesy of Special Collections, University of Delaware Library, Newark, Delaware.)

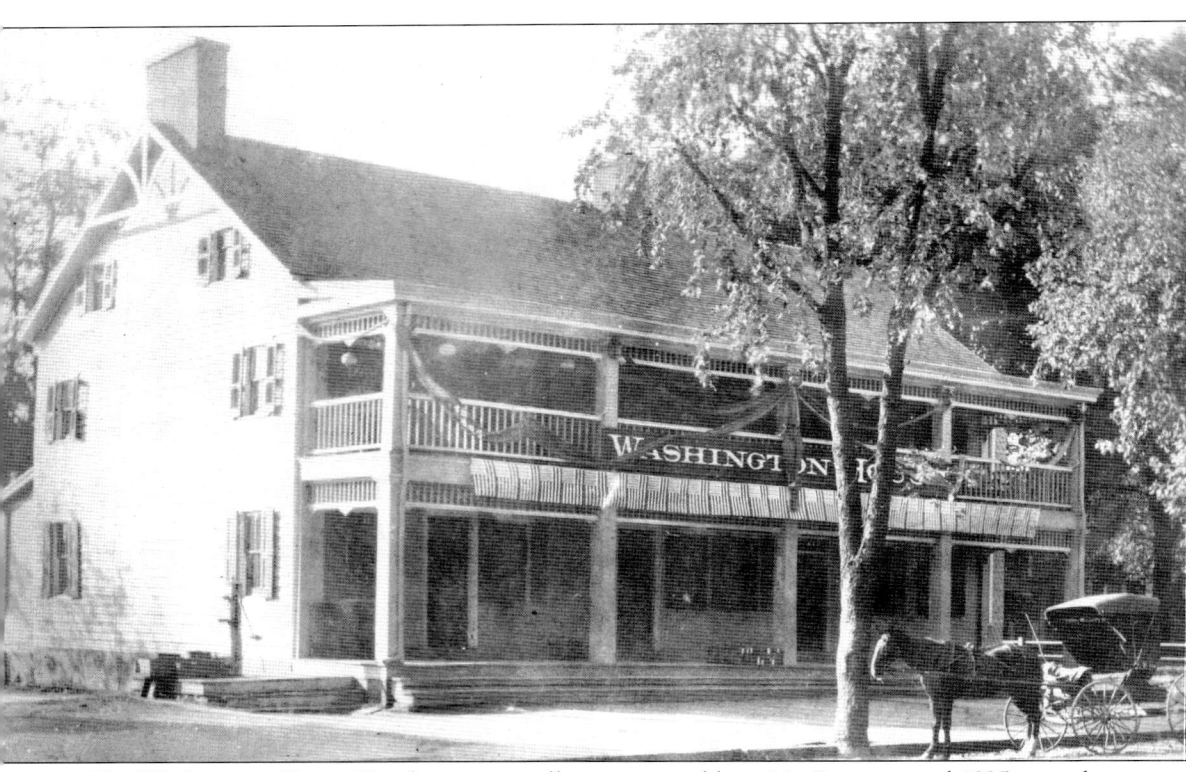

The Washington House Hotel was originally constructed by a Mr. Betts around 1825 near the site of Newark's market house. In 1838, the building was sold to a Mr. Blandy, who remodeled the existing building and constructed an addition. This photograph was taken around 1910 by Alice Leak. In the early 1920s, the hotel was purchased by Vic Willis, a future baseball hall of famer, who remodeled and expanded the building in 1926, adding a new front and an additional five rooms. The building served as a hotel well into the 20th century and was later transformed into a tavern in 1964, when it became known as Jimmy's Tavern and later Merle's Tavern. In 1972, it became the Stone Balloon, a local tavern that sponsored national music acts. In 2006, it was demolished to make way for the Washington House Condominiums. (Courtesy of Special Collections, University of Delaware Library, Newark, Delaware.)

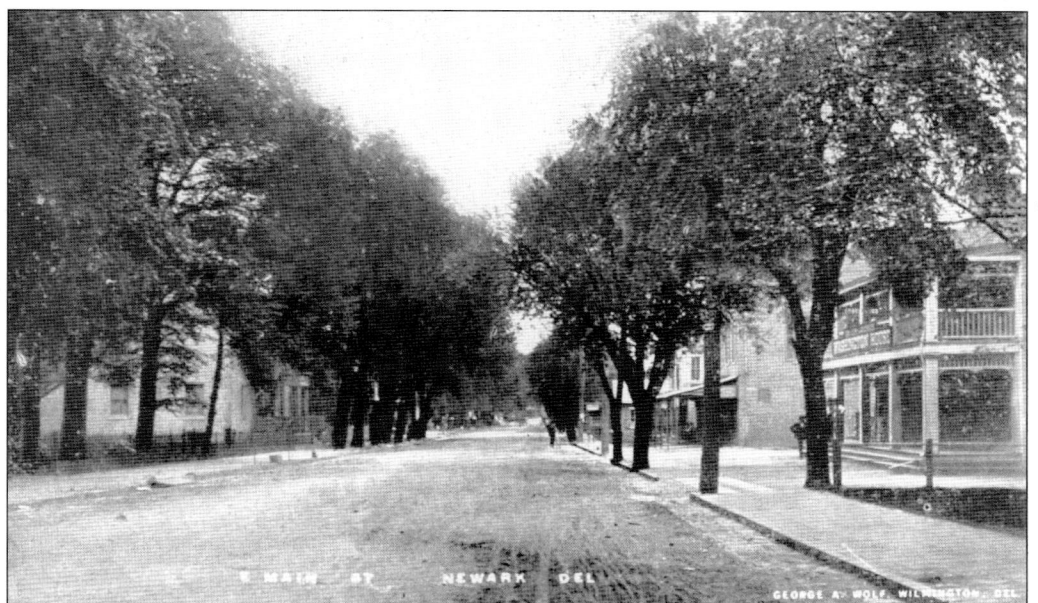

Taken prior to 1914, this image looking east depicts a tree-lined Main Street before paving. During this time, Main Street remained largely residential, and sleigh races were often held on the unpaved street throughout the winter months. The Washington House Hotel is clearly visible on the far right. (Courtesy of Special Collections, University of Delaware Library, Newark, Delaware.)

The National Bank of Newark was organized in 1855. Daniel Thompson was the first president of the institution, with James Martin, Frederick Curtis, William McClelland, James Miles, Benjamin Caulk, John Miller, Solomon Leeche, and Joseph Hossinger acting as commissioners. The bank later became Farmers Trust Company, and in 1952, it became a branch of Wilmington Trust. (Courtesy of Special Collections, University of Delaware Library, Newark, Delaware.)

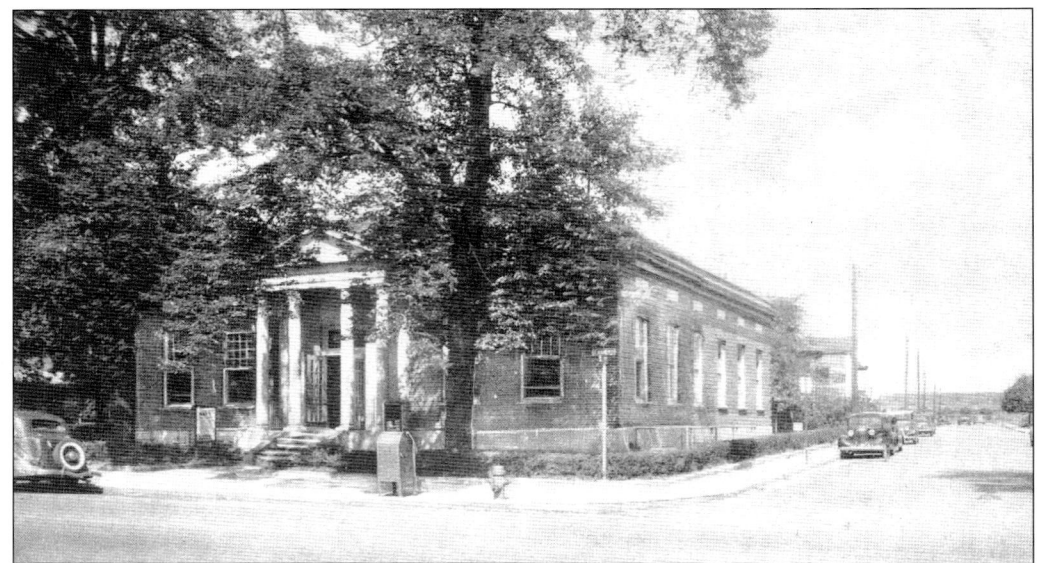

Located on the corner of Main and Center Streets, the post office building was constructed in 1929. Postal service came to Newark in 1808, with Alexander McBeath serving as postmaster and his home as the post office. The post office has also operated out of the Exchange Building and the Opera House. (Courtesy of Special Collections, University of Delaware Library, Newark, Delaware.)

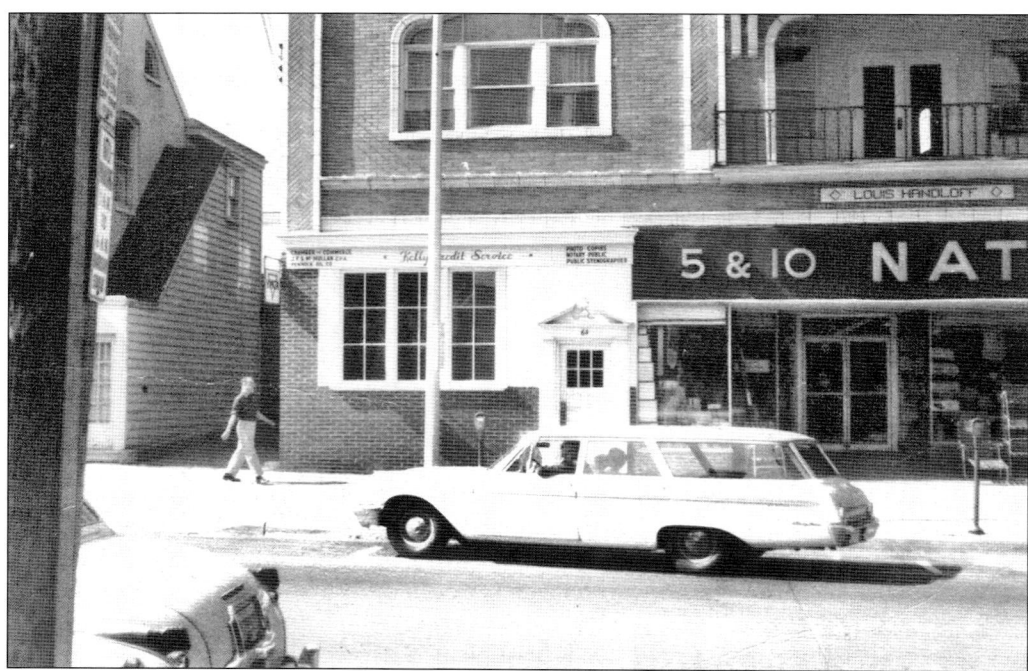

The National 5-and-10¢ store and building have been owned by the Handloff family for generations. The second-floor balcony has been enclosed, and many internal changes have been made to the store. It remains one of the few stores to continue in business on Main Street for over 50 years. (Courtesy of Sylvia Dale Williamson.)

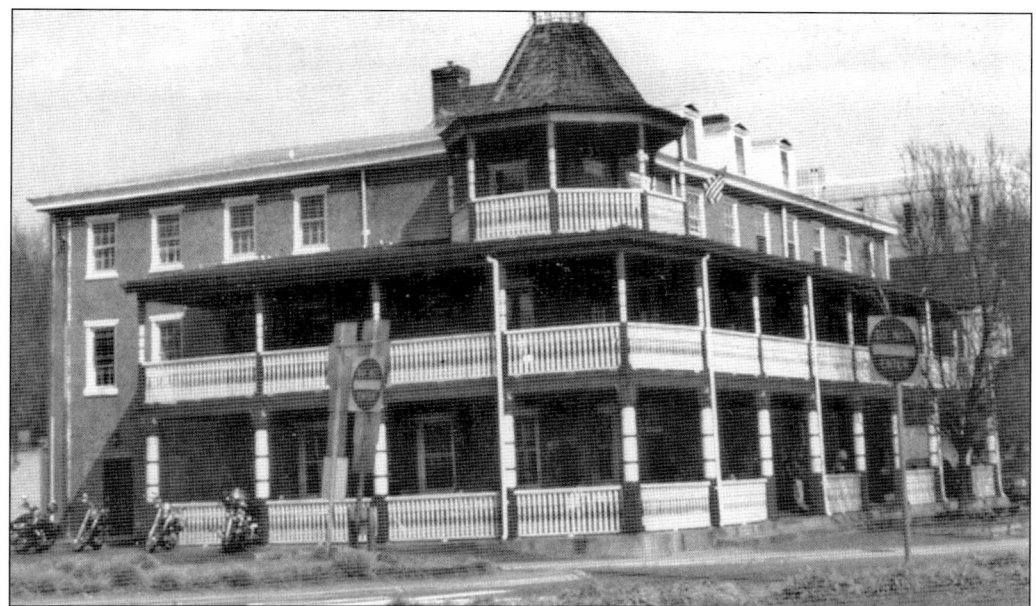

The Deer Park is Newark's oldest hotel. In fact, a hotel has stood on the site since the mid-18th century. Originally known as the St. Patrick Inn, it was later owned by the Pritchard family and for almost a century was known as the Pritchard Inn. In 1848, the inn was purchased by James Martin, who demolished it and in 1851 constructed the current building, which he named the Deer Park. (Courtesy of Richard L. Dayton.)

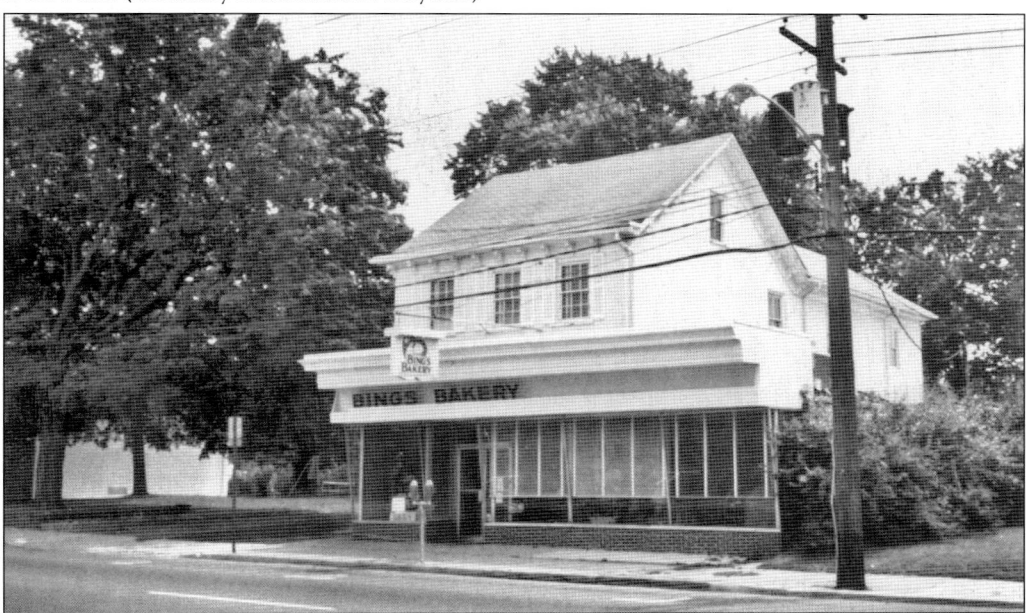

In 1946, Russell and Selena Bing took over Fader's Bakery at 57 East Main Street and renamed it Bing's Bakery. In 1955, the Bings moved their bakery farther east on Main Street to its current location. Selena Bing continued to manage Bing's Bakery after her husband's death in 1979, but in 2005, failing health led her to sell the business to a longtime employee. (Courtesy of Richard L. Dayton.)

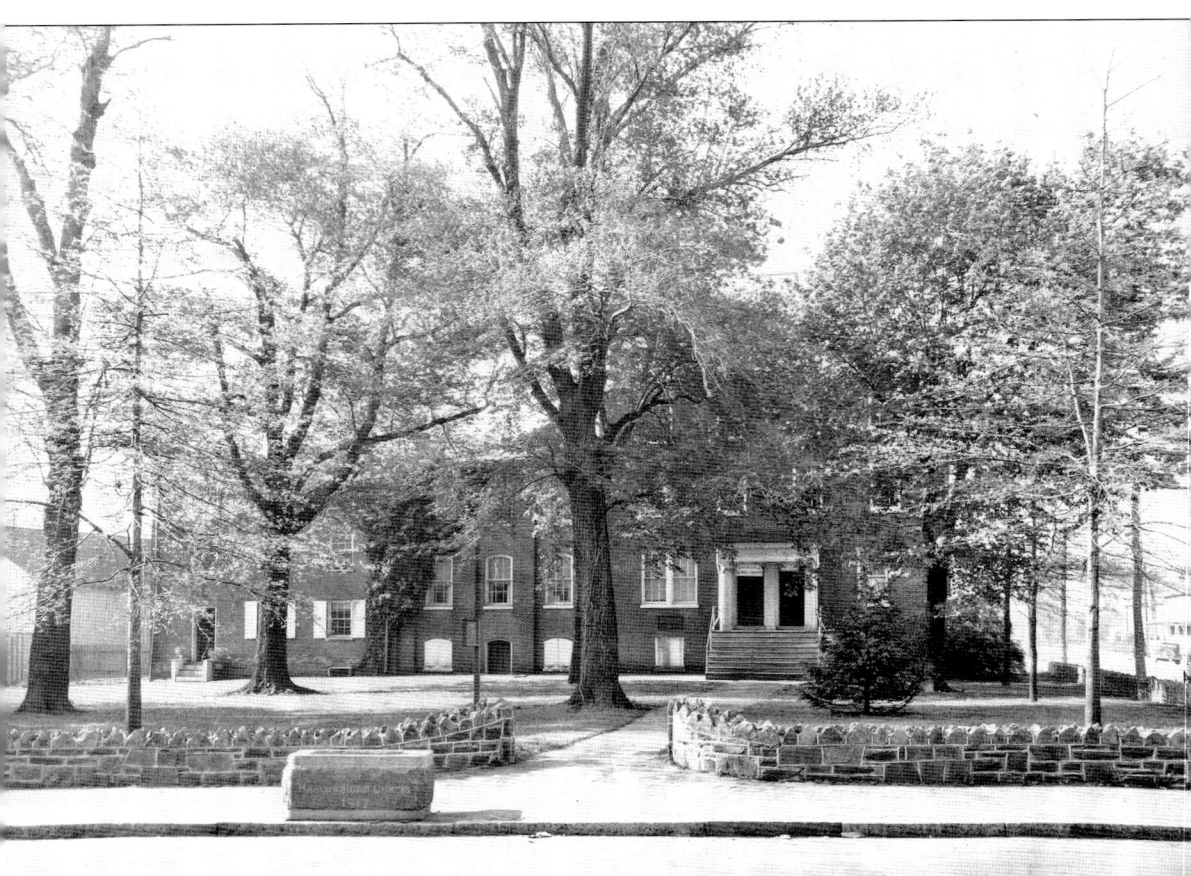

The Academy Building has served the community in a variety of ways since its construction in 1843, including housing the town library. Formed some time before 1858, the Newark town library was housed at various locations throughout Newark, including in the Odd Fellows Hall. In 1893, eight women founded a reading club that evolved into the New Century Club. The club members established a committee to work with the library association and expand the library with the assistance of Wilbur T. Wilson, who was serving as town librarian. A subscription library, the collection was moved to the Academy Building in 1920, where it remained until 1957, when it was moved to a building on Elkton Road. It became a free lending library in 1932. In 1969, the library commission purchased property at East Main Street and Delaware Avenue on which to build a larger library. Completed in 1974, the Newark Free Library became part of the county library system. This location still serves as Newark's library. (Courtesy of Special Collections, University of Delaware Library, Newark, Delaware.)

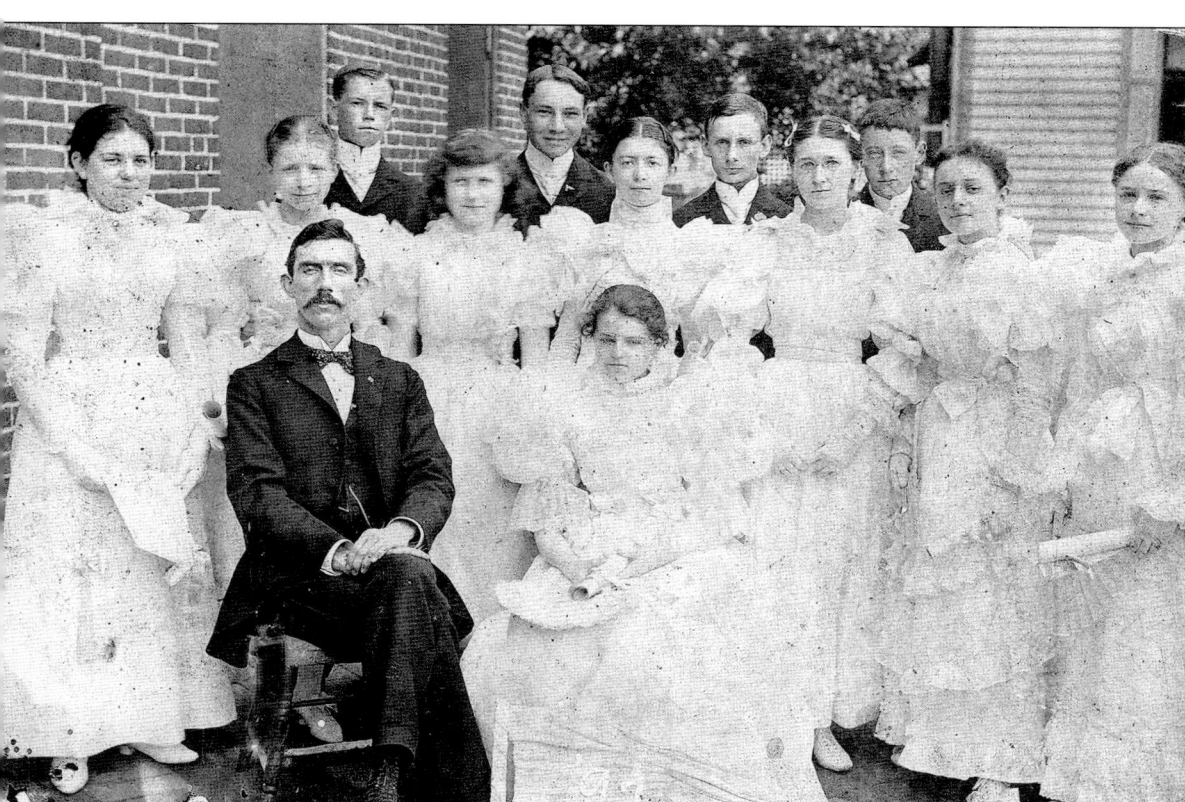

Graduating its first class in 1893, Newark High School was originally located at 83 East Main Street. The building was constructed by the town in 1884 to serve as a public school, with lower grades on the first level and high school classes on the second level. This photograph of the 1897 graduating class features Prof. A. Lee Ellis and class valedictorian Louise Staton in front. Staton would later find work as a teacher and in 1902 married Everett Johnson, founder of the *Newark Post* and the Press of Kells. Other students pictured include Charles Murphey, Ethel Ferguson, and Myrtle Whiteman. In 1898, the school moved to larger quarters in the recently closed Newark Academy building, where it remained for many years. (Courtesy of Special Collections, University of Delaware Library, Newark, Delaware.)

In 1741, Francis Alison, a Presbyterian minister, founded a school in New London, Pennsylvania. In 1767, the school was moved to Newark and became the Newark Academy. Gradually expanding to include a college, in 1869, the academy separated from the college and continued to operate as a separate institution until 1898. The college was later renamed the University of Delaware. (Courtesy of Special Collections, University of Delaware Library, Newark, Delaware.)

Jane Maxwell was the daughter of local civil engineer James Maxwell. Born in Peru in 1874, Jane Maxwell was a music teacher who lived at 257 West Main Street. She was related to Wilbur T. Wilson, who was also a civil engineer and with whom she lived until his death in 1942. (Courtesy of Special Collections, University of Delaware Library, Newark, Delaware.)

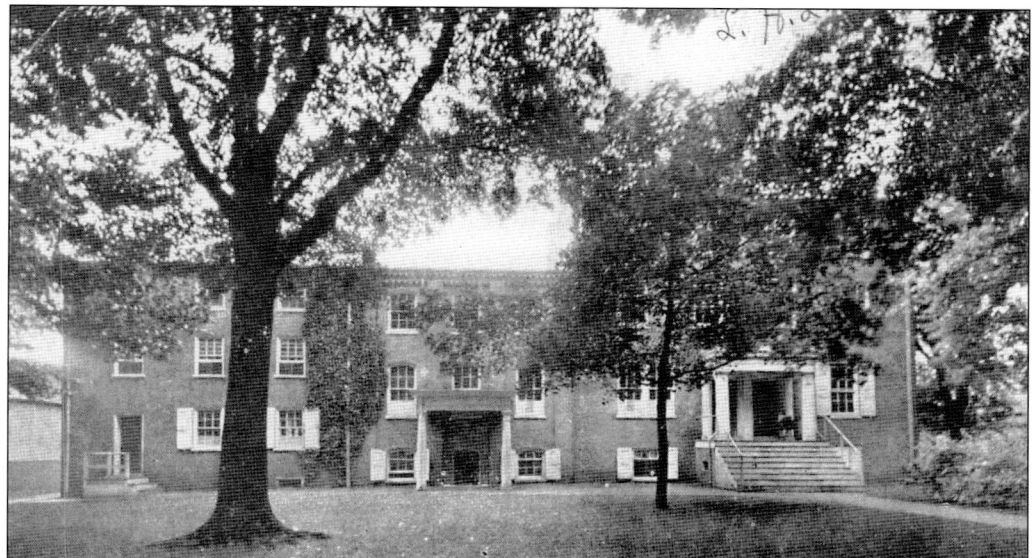

This image of Newark High School was taken sometime between 1900 and 1907. The building was originally constructed in 1841 on the site of the original Newark Academy. In 1889, it was used as a public high school. After 1925, when a new high school building was constructed, the building was used for a variety of purposes and was eventually purchased by the university in 1976. (Author's collection.)

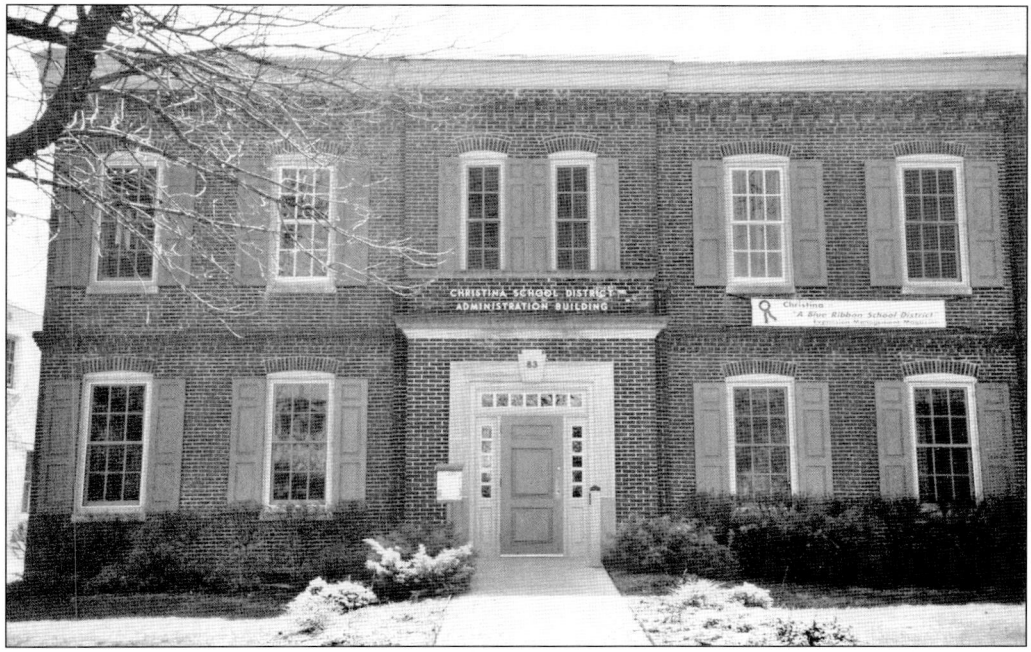

The administration building of the Christina School District was located at 83 East Main Street until 2005. Albert G. Lewis purchased the land on which the building stands in 1844. Upon Lewis's death in 1883, this portion of the Lewis family property was sold at auction and purchased by Samuel M. Donnell, who donated it to the school district. (Courtesy of Sylvia Dale Williamson.)

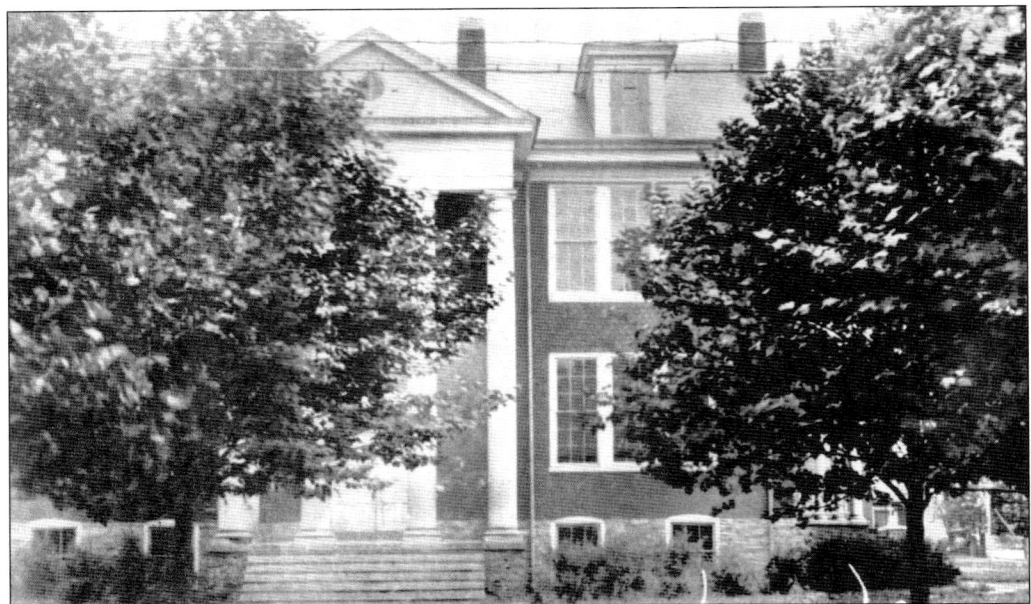

In 1907, the district built this elementary school on the corner of Delaware Avenue and Academy Street, while the high school remained in the Academy Building. This eight-room schoolhouse remained in use until after World War II, when the district constructed Central Elementary School on Academy Street in 1950. (Courtesy of Special Collections, University of Delaware Library, Newark, Delaware.)

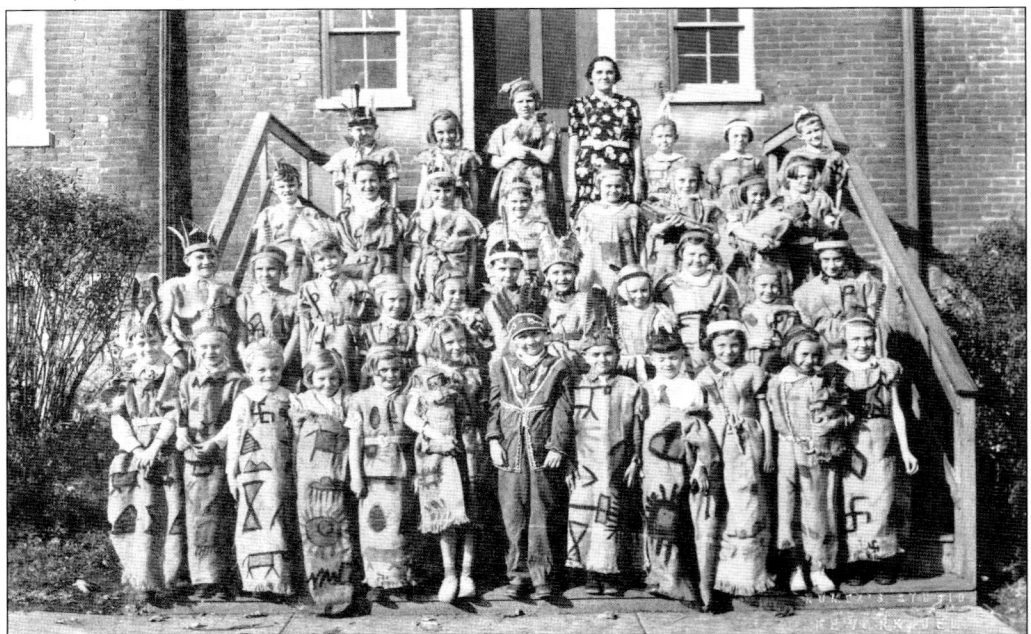

Taken sometime in the 1930s, this photograph features schoolchildren most likely at the elementary school on the corner of Delaware Avenue and Academy Street. An increasing number of students led the district to construct the school in 1907. (Courtesy of Special Collections, University of Delaware Library, Newark, Delaware.)

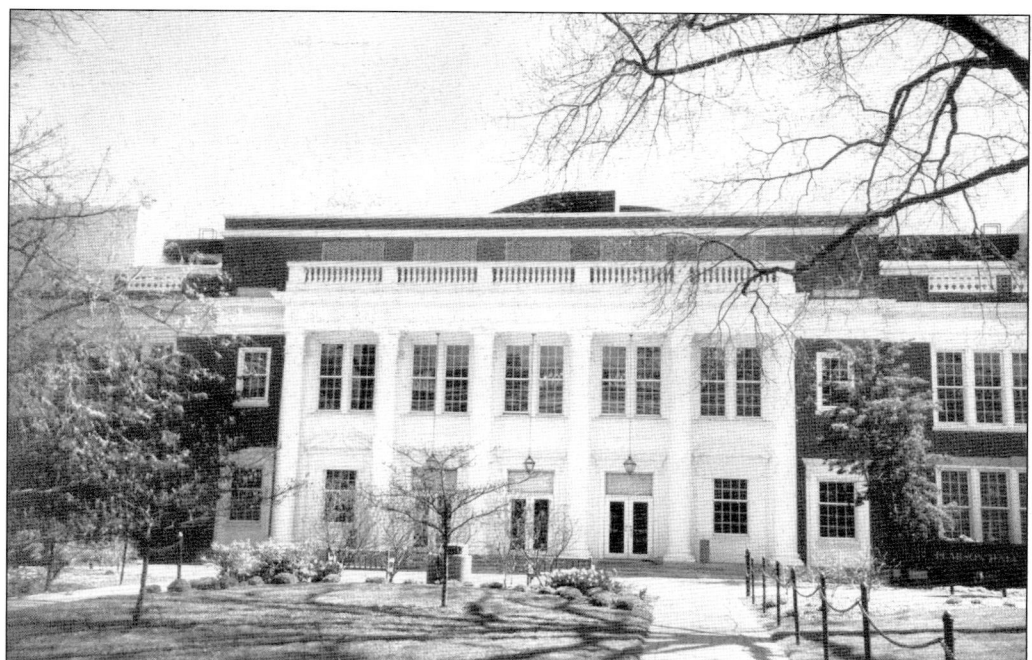

Originally constructed in 1925, this building on the corner of Academy Street and Lovett Avenue served as Newark's high school until the mid-1950s, when a new school was built on East Delaware Avenue. This building was sold to the University of Delaware in 1955. Renamed Pearson Hall, it now houses the Department of Geography and the University Archives. (Courtesy of Sylvia Dale Williamson.)

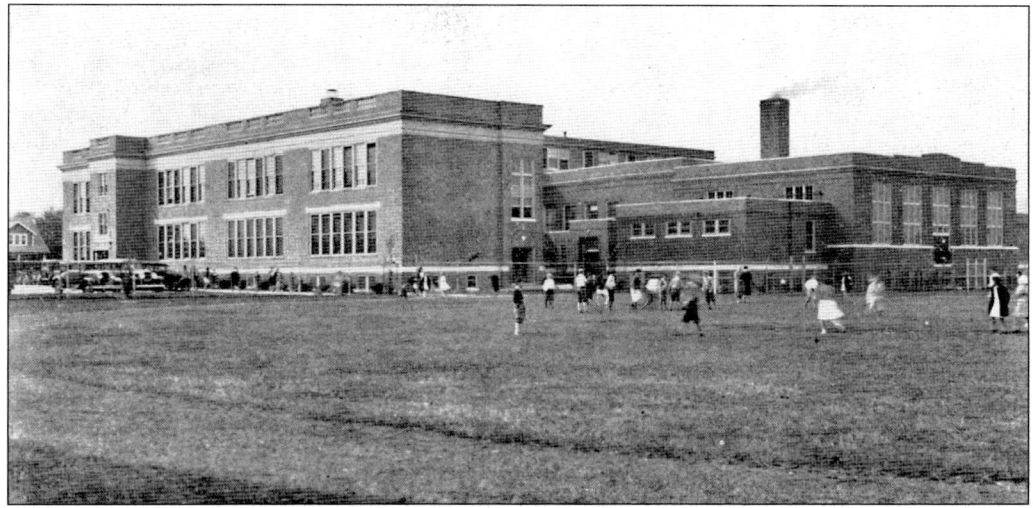

As Newark's population expanded, the first school constructed to meet the community's educational needs was built near the corner of Academy Street and Lovett Avenue and opened in 1925. The school contained both junior and senior high schools and a portion of the elementary school. The building was frequently expanded to meet student needs. This photograph of the rear portion of the school depicts the new auditorium and gymnasium. (Author's collection.)

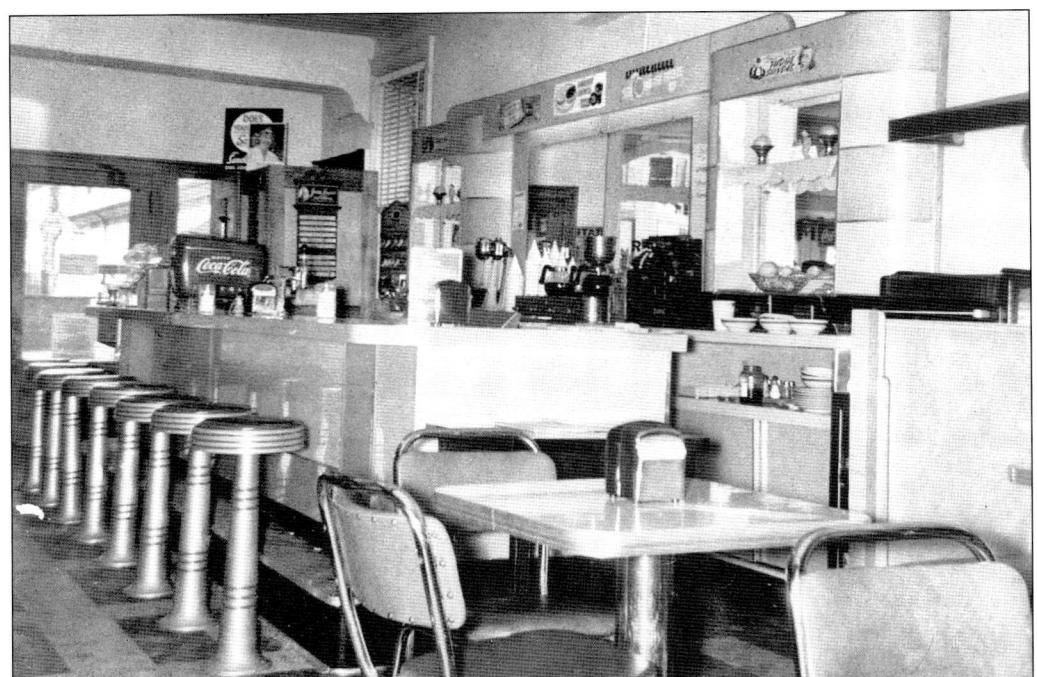

According to census reports, George Rhodes was born around 1880. In 1911, he took over operation of Eben Frazer's drugstore. Throughout the 1930s, the drugstore also served as the college bookstore. Because it was located so close to campus, the drugstore was an integral part of college life. This interior view dates from the 1950s. (Courtesy of Special Collections, University of Delaware Library, Newark, Delaware.)

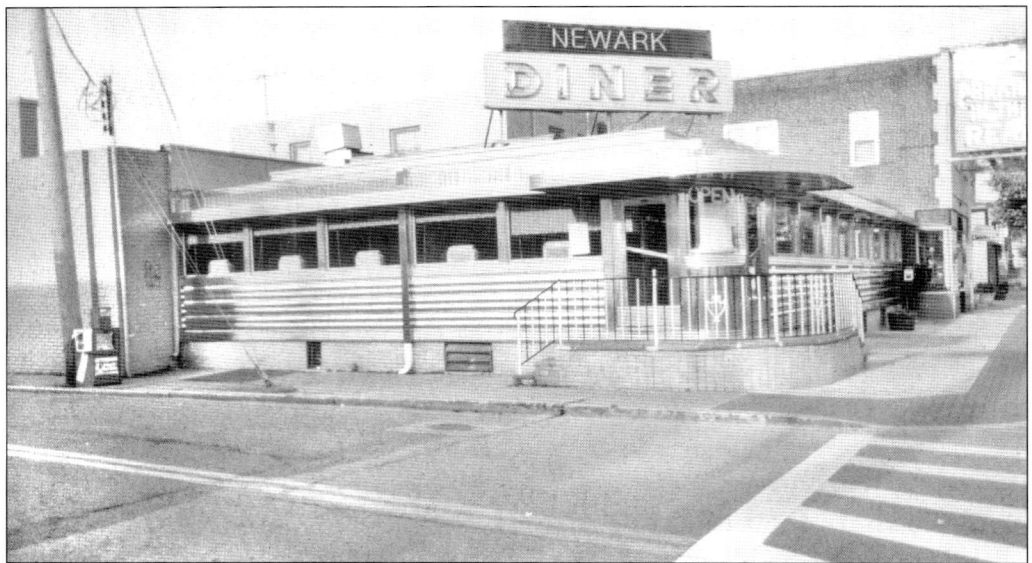

This photograph of Newark Diner was taken by Asa Pieratt in July 1998. Prior to this time, the diner had been called Jude's Diner and throughout the 1970s and 1980s was known as Jimmy's Diner. Currently known as the Korner Diner, the facade is a distinctive feature of Newark architecture. (Courtesy of Special Collections, University of Delaware Library, Newark, Delaware.)

This undated image was taken on the lawn of the Academy Building and appears to be a class photograph. Behind the students, buildings along Main Street can be seen. The large building to the left is the Green Mansion, and to the right of the mansion is the Bank of Newark building. Both of these buildings are still in use. (Courtesy of Richard L. Dayton.)

The large building on the left was known as the Newark Opera House. It was constructed by David Caskey in 1885 and was originally called Caskey Hall. In the early 1890s, Caskey Hall housed a general store and barbershop on the ground floor and a public hall for the presentation of live theater, music, and movies on the second floor. (Courtesy of Special Collections, University of Delaware Library, Newark, Delaware.)

ANNOUNCEMENT

After sixty years in the Powell family the concern Powell's Ice Cream Company has been purchased by James H. Skinner, formerly with Gifford Ice Cream Company of Silver Spring, Md.

To my friends and customers I wish to extend my appreciation and thanks for the courtesies extended me during the years and hope you will continue the same with my successor.

WALTER R. POWELL

—•—

Opening Day
At

Powell's Ice Cream Plant Store
Now Operated by

JAMES H. SKINNER

Friday June 20 – 12 Noon till 9:30 p.m.

SPECIAL OPENING DAY FEATURES

Free Cones To Children With Parents

Free "Fresh Fruit Punch"

½ Gallon Ice Cream $1.00 – Reg. $1.20

For Door-to-Car Service enter Powell's Lane from Delaware Avenue

Get Your Ice Cream Right On The Spot Where It Is Made

Quarts – Pints – Sliced Brick – Cups – Dishes

Since 1890

POWELL'S ICE CREAM CO.
Powell's Lane
Newark

Powell's Ice Cream Company was opened at 35 East Main Street in 1897 by George Powell, who originally began selling ice cream and oysters in 1887, when he was 27 years old. In 1909, Powell's son, Walter, took over the family business and operated Powell's restaurant in addition to purchasing various rental properties within Newark and operating an ice cream factory. Sometime during these years, Powell's moved to 43–45 Main Street, the present location of the Galleria. Walter's stepson, Grover Surratt, took over the business sometime in the 1940s, and in 1950, the business was sold to James H. Skinner, who retained the name until the store was converted into a malt shop in the 1960s. Both Powell and his wife continued to live at 43–45 Main Street until their deaths. The building was demolished in the 1990s to make way for the Galleria. (Courtesy of Special Collections, University of Delaware Library, Newark, Delaware.)

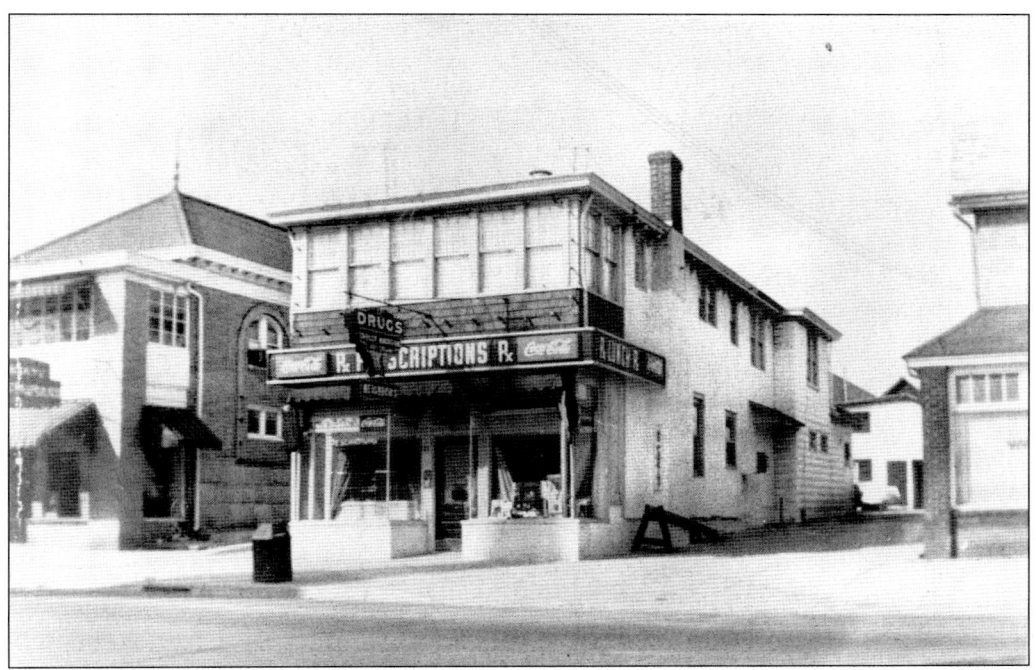

Hugh Gallagher was a local developer and realtor who was active in Newark civic affairs. In 1951, he left his position with Union Park Motors, Inc., and founded his own development company. Shortly thereafter, Gallagher began construction of Silverbrook, Newark's first subdivision. In 1961, he opened his own realty company at 74 East Main Street. At the time the building was purchased by Gallagher, it housed a drugstore. During the 1920s, the site served as a gas station, and the building is believed to have been built in the 1890s. These photographs show the building as the drugstore and after completion of renovation. Gallagher sold the real estate agency to B. Garry Scott in 1979 but retained ownership of the building. (Courtesy of Special Collections, University of Delaware Library, Newark, Delaware.)

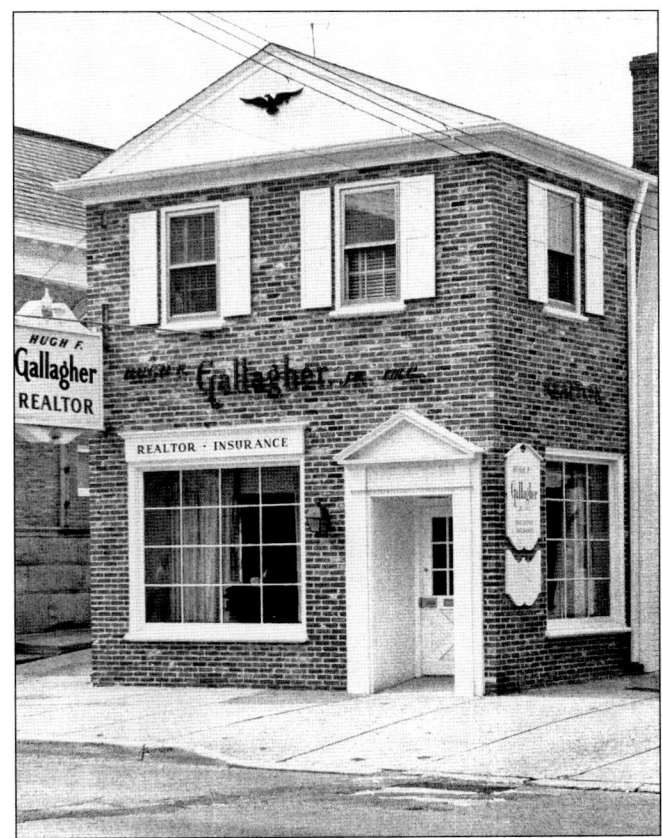

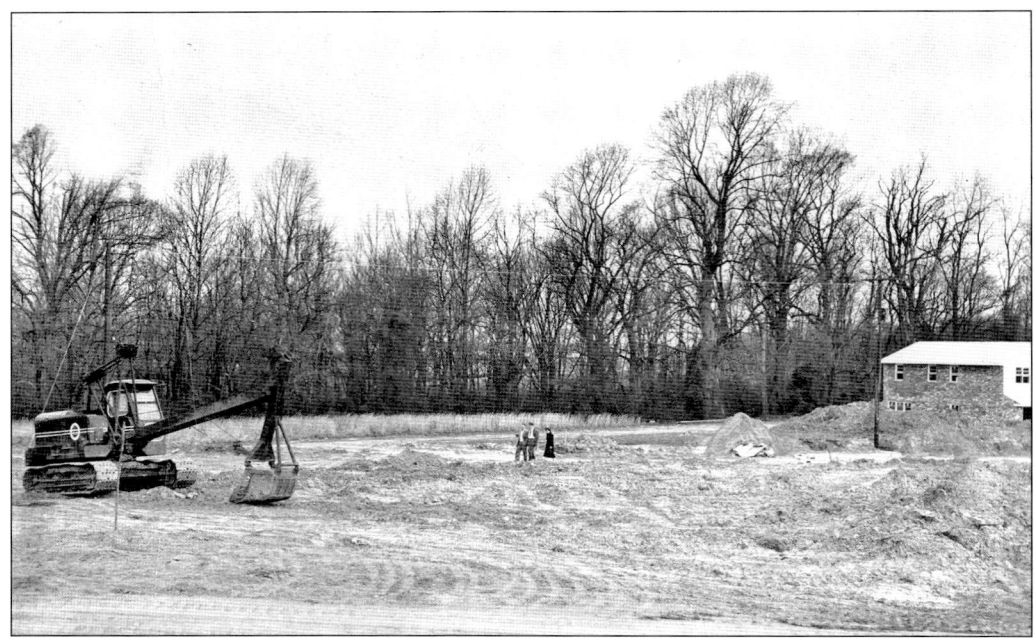

These photographs taken in 1955 document the construction of the first homes that would eventually become the suburban development of Silverbrook. Located just southwest of Newark, the development was designed by Hugh Gallagher Jr. In 1951, Gallagher left his position as a president of customer service for Union Park Motors, Inc., to delve into real estate. In that year, he established the Silverbrook Development Corporation. Silverbrook became the first suburban development in the Newark area. Construction was completed in 1955. Following the success of Silverbrook, Gallagher began developing Oaklands on 91 acres purchased from the Wilson family estate. (Courtesy of Special Collections, University of Delaware Library, Newark, Delaware.)

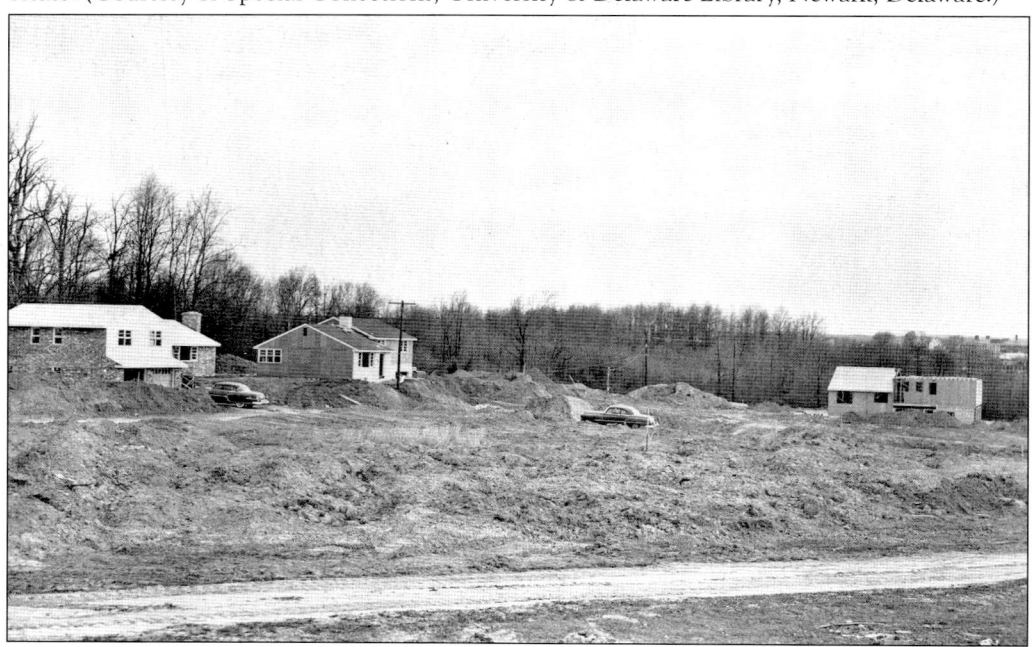

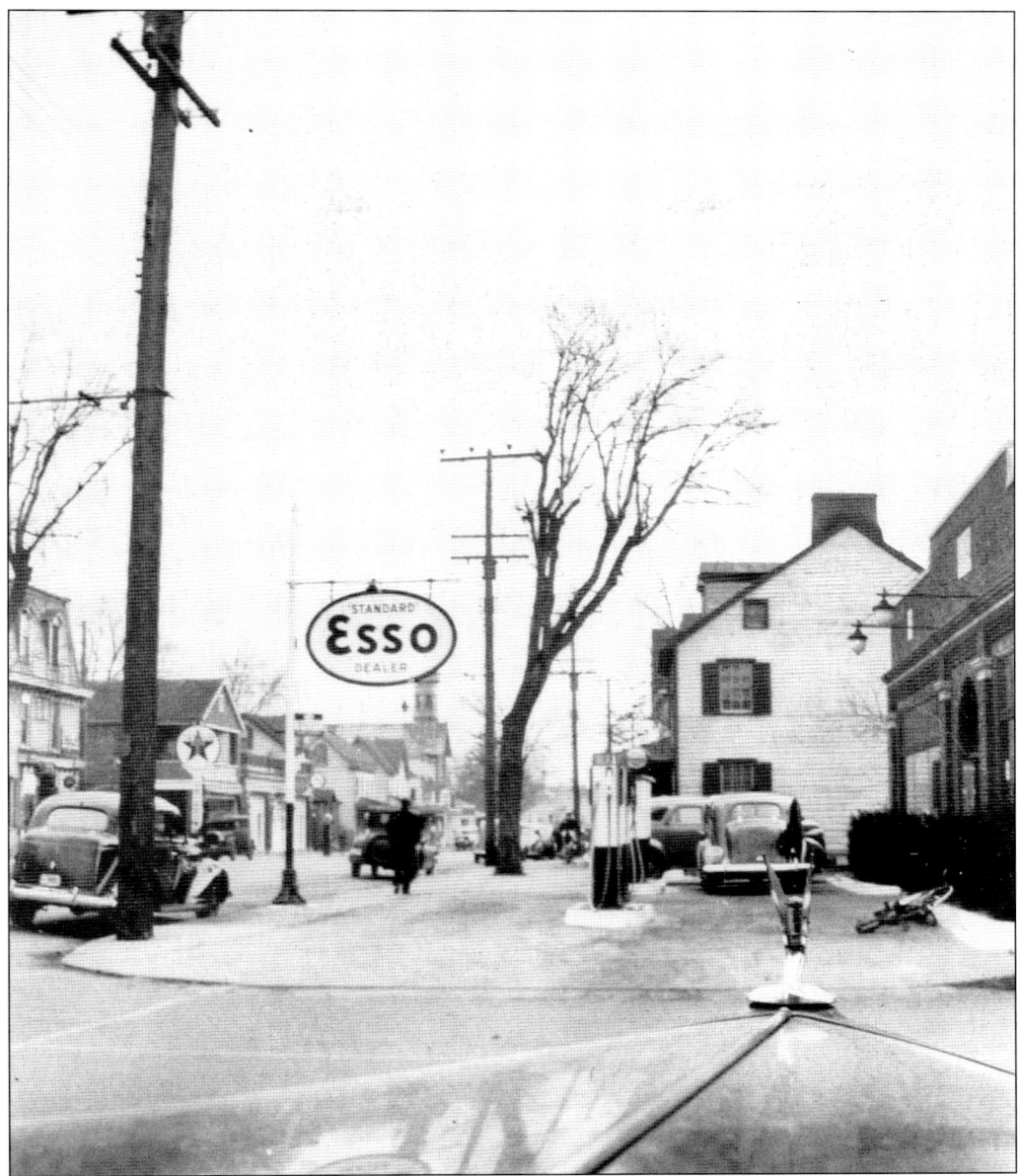

Looking east along Main Street from the corner of Haines Street, this photograph was taken by Adele Smith in the late 1930s. The Esso gas station is currently a Starbucks coffee shop and tanning salon. Klondike Kate's is visible on the far left. Klondike Kate's is on the site of the former Three Hearts Tavern, which was operated by Ebenezer Howell. In 1797, the tavern became known as Hossinger's Tavern and was operated by Joseph Hossinger. By the early 1820s, the building had become an inn and in 1858 was called the Newark Hotel. In 1880, the hotel was demolished by the Newark Hall Company, and a three-story building with a basement was constructed. Known as the Exchange Building, it had commercial shops on the ground floor and office space, apartments, and a meeting room on the second floor. At various times in the late 19th century, the location was home to Newark Grange's cooperative store and Newark's post office. (Courtesy of Special Collections, University of Delaware Library, Newark, Delaware.)

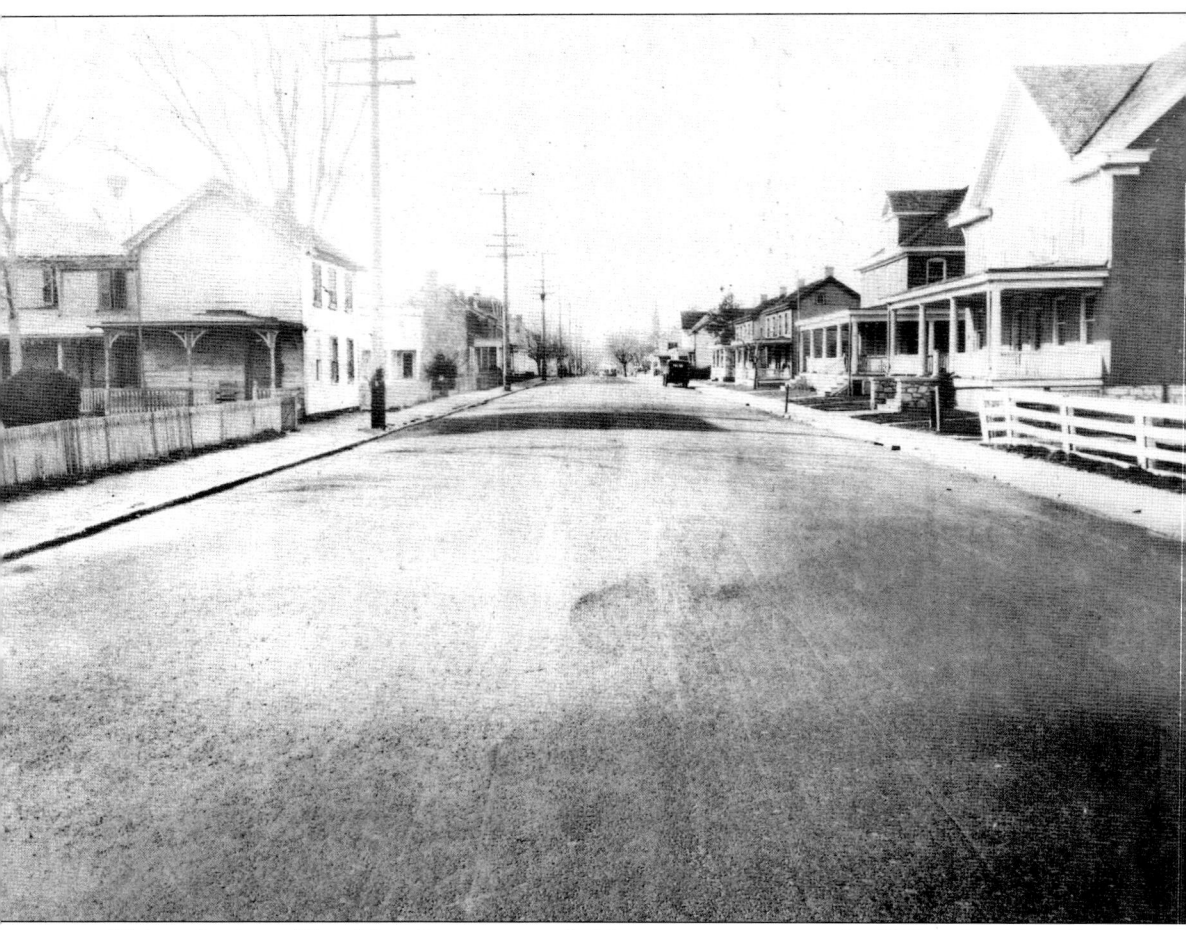

This early view of East Main Street was probably taken sometime in the 1920s, after Main Street had been paved and electric lines run. Looking from the east end of Main Street, the steeple of St. John's Roman Catholic Church can be seen in the distance. Unlike the middle area of Main Street, the eastern portion developed at a slower rate. Among the first non-residential ventures established east of Chapel Street were Samuel B. Wright's lumber company, which later evolved into the Newark Lumber Company, and the Village Presbyterian Church, which later became St. John's Roman Catholic Church. Many of the residential homes that once lined this portion of Main Street are still in use, although many have been converted into office space. The second building from the right now houses office space and an antique store. (Courtesy of Richard L. Dayton.)

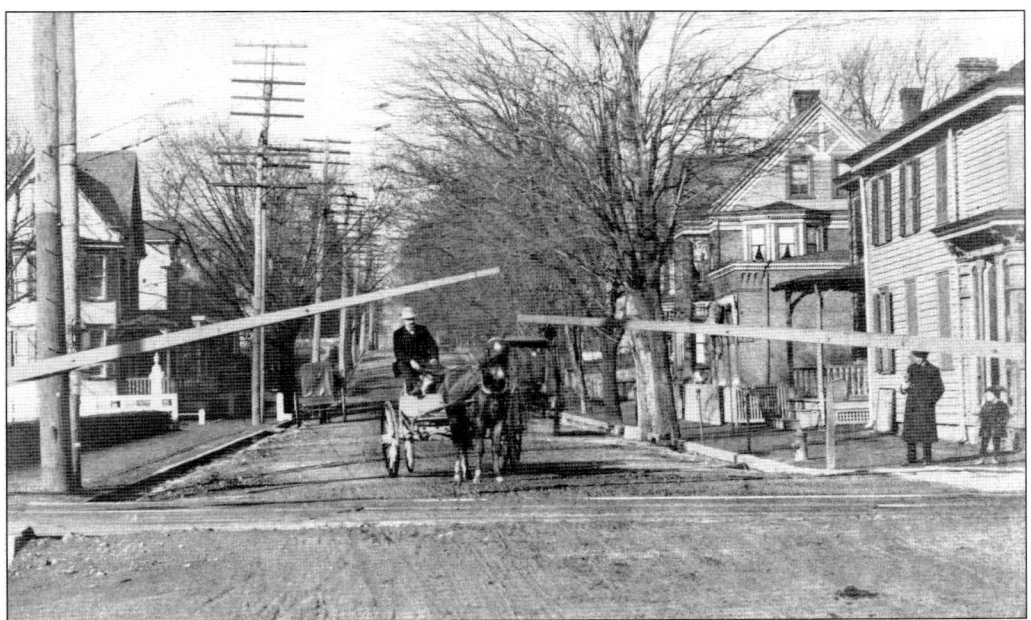

The area west of the Baltimore and Ohio Railroad tracks between Main Street and New London Avenue was known as Quality Hill. This view was taken from the foot of Quality Hill in the early 1900s, prior to the paving of Main Street but after the arrival of electricity, as evidenced by the power lines. (Courtesy of Special Collections, University of Delaware Library, Newark, Delaware.)

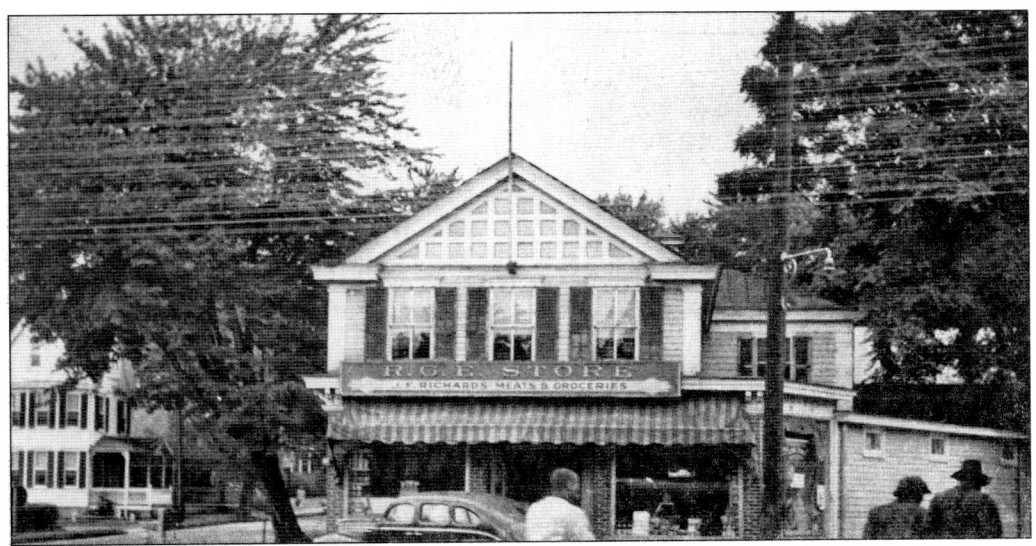

Taken in August 1942, this photograph depicts Richards grocery store. The home of Mr. and Mrs. Edward Ginther at 121 West Main Street is visible on the left. The juncture of West Main Street and New London Road has previously housed Litton's Restaurant and for many years has been home to Wonderland Records. (Courtesy of Special Collections, University of Delaware Library, Newark, Delaware.)

This building on Main Street, located almost directly across from Center Street, is an excellent example of how the city of Newark attempts to integrate historic buildings with new development. Originally known as Wollaston's store and later as Newark Farm and Home, it was a hardware store from the 1950s through the 1970s. Today the Newark Farm and Home building houses apartments on the second story while utilizing the ground floor as retail space, including a bank. Many of the original architectural features of the building were retained during renovation, with additions made on each side of the property. (Courtesy of Special Collections, University of Delaware Library, Newark, Delaware.)

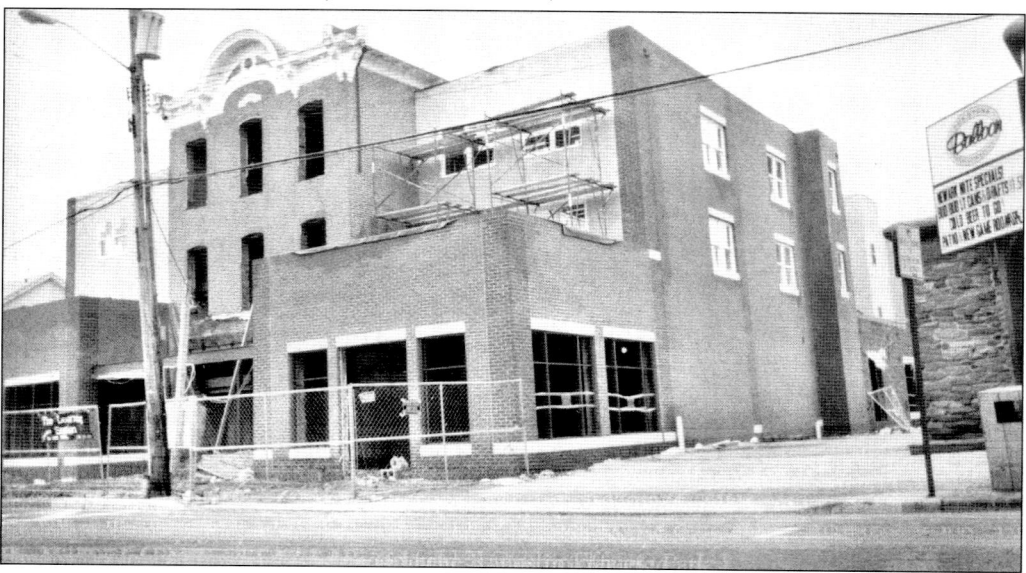

Two

Historic Homes and Significant Architecture

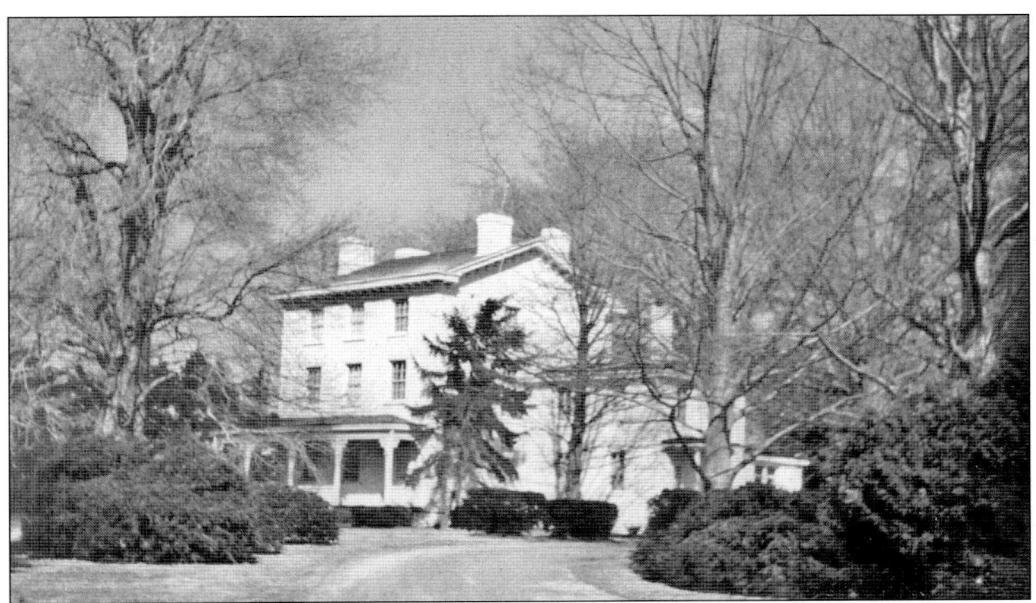

The history of the property on which the Edward R. Wilson House sits can be traced back to 1703, although the home probably dates from around 1860. Once belonging to Rathmell Wilson and his son, Edward R. Wilson, the property, including several barns, orchards, and fields, was acquired by the University of Delaware in 1907 to be used as a teaching farm for agriculture students. (Courtesy of Richard L. Dayton.)

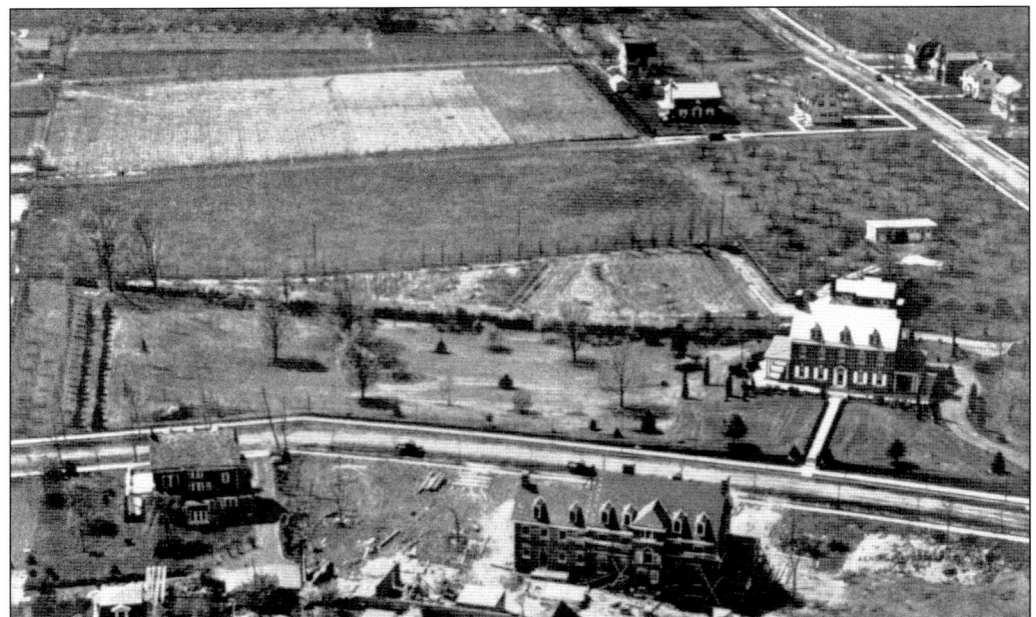

This aerial view of the home of John Pilling Wright on the right was taken sometime in the early 1920s. Wright was active in university affairs and was a trustee from 1934 to 1946. His wife, Elizabeth Johnson Wright, donated the home to the university in 1961, and it has been the official president's residence since that time. (Courtesy of Richard L. Dayton.)

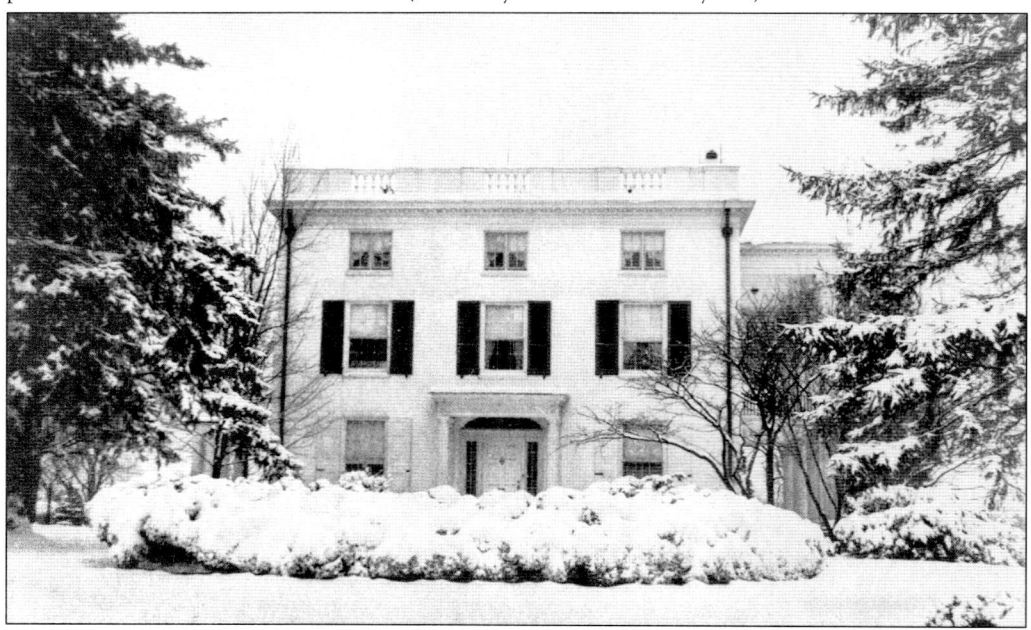

This home, known as the Granite Mansion, was built for James Miles in 1844 or 1845. In 1924, it was purchased by Norris Wright, who, with his brothers, owned the Continental Diamond Fibre Company. Wright renovated the home and made significant alterations. The home and 14 acres were purchased by the First Presbyterian Church in 1955. The mansion was demolished in 1988. (Courtesy of Richard L. Dayton.)

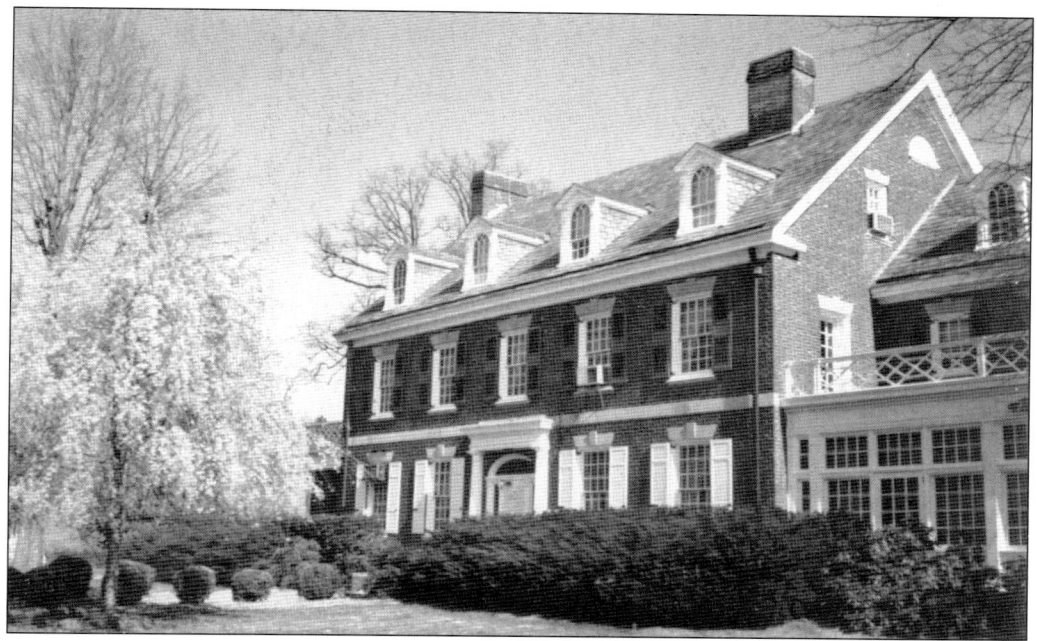

Originally the home of Marian and Ernest Brinton Wright, this house at 44 Kent Way was constructed by the Wrights in 1926. The home was donated to the university following the death of Marian Wright in 1966. Beginning in 1971, the home was opened as a fine dining establishment for the university community. Known as the Blue and Gold Club, it is now a members-only organization. (Courtesy of Richard L. Dayton.)

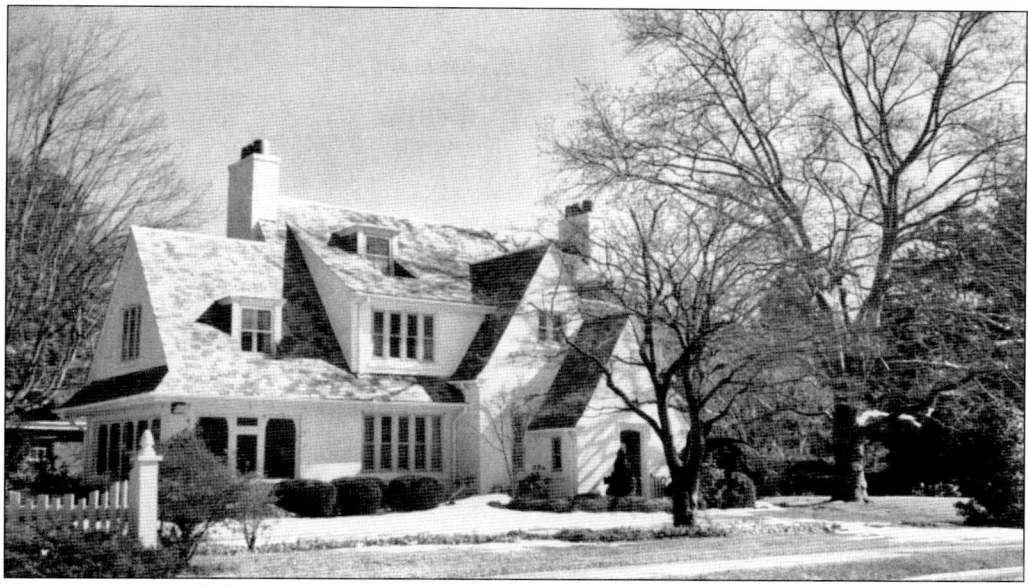

This home was built for Elsie Wright. Born in 1883, Wright was the older sister of J. Pilling, Ernest, and Norris Wright. Elsie Wright's father, Samuel, organized the American Hard Fibre Company with her maternal grandfather, John Pilling, in 1894. Samuel also founded the Continental Diamond Fibre Company with his son J. Pilling. By 1930, Elsie Wright was living in this home at 235 Orchard Road. (Courtesy of Richard L. Dayton.)

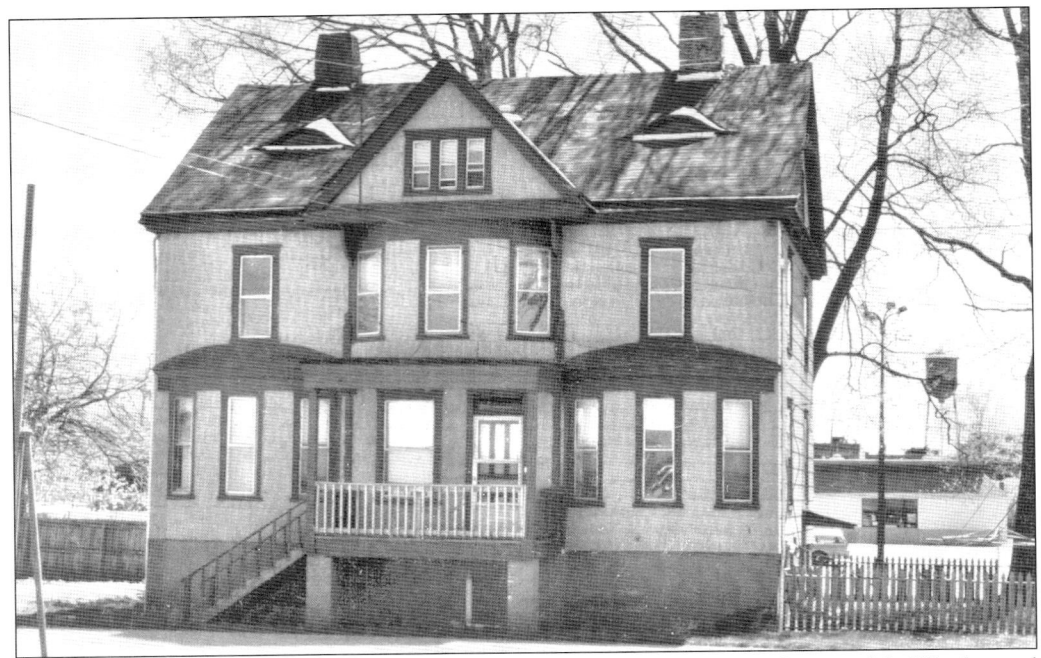

This home was originally owned by Samuel B. Wright, the father of Samuel J. Wright and grandfather of John Pilling Wright, who founded the Continental Diamond Fibre Company. Samuel B. Wright operated a blacksmith and wheelwright shop on the corner of Main and South Chapel Streets and eventually founded the Newark Lumber Company. He constructed this home next door. When the lot was sold, the home was moved around the corner to face South Chapel Street. After serving as a rental property for many years, it was moved farther south on Chapel Street in 1999 and converted into apartments. (Courtesy of Richard L. Dayton.)

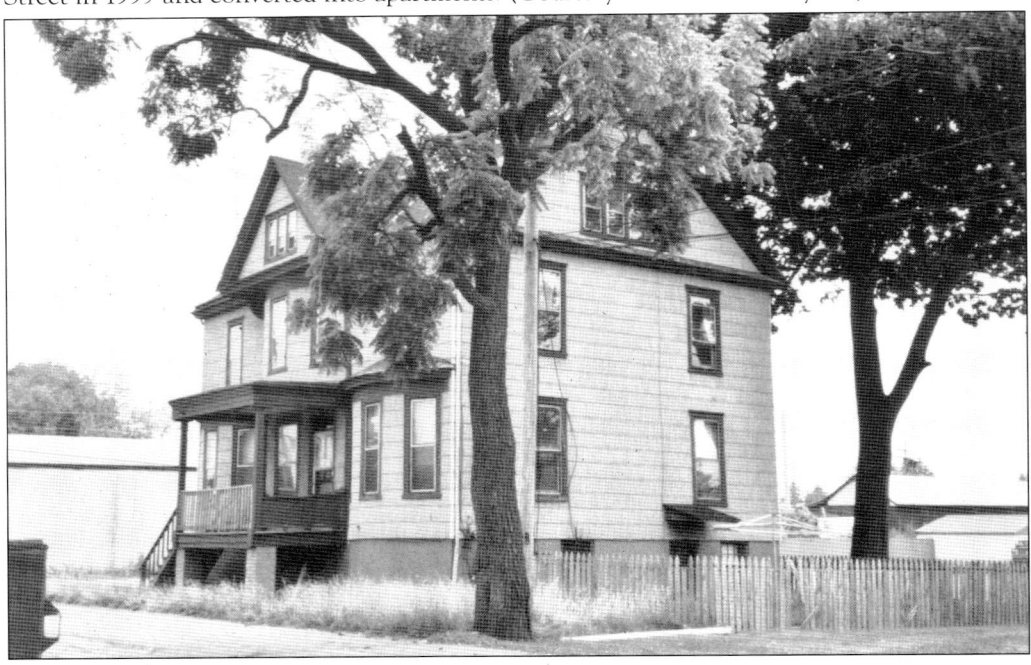

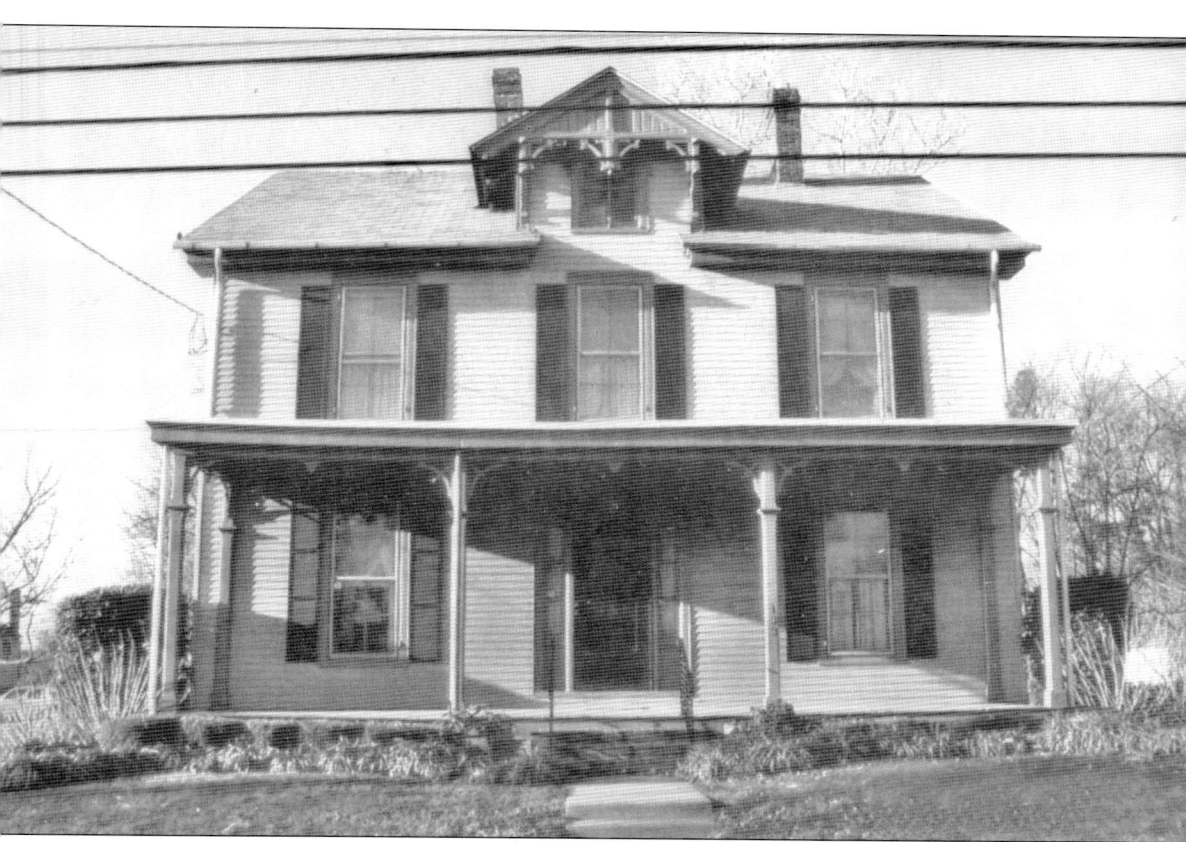

This house at 133 West Main Street is currently the home of Audrey and Robert T. Jones Jr. and was constructed near the end of the 19th century. The home once served as a Presbyterian manse. After operating a funeral home for years at the present location of the University of Delaware's Harter Hall, in 1916, Robert T. Jones Sr. purchased property at 122 West Main Street and established a funeral home there. Located near the junction of West Main Street and New London Avenue, the site was once the home of Theodore Armstrong, a merchant. Jones's son, Robert T. Jr., continues the family business today and partnered with Robert T. Foard in 1990. The funeral home is the longest-operating funeral home in the city of Newark and continues to serve the community. (Courtesy of Richard L. Dayton.)

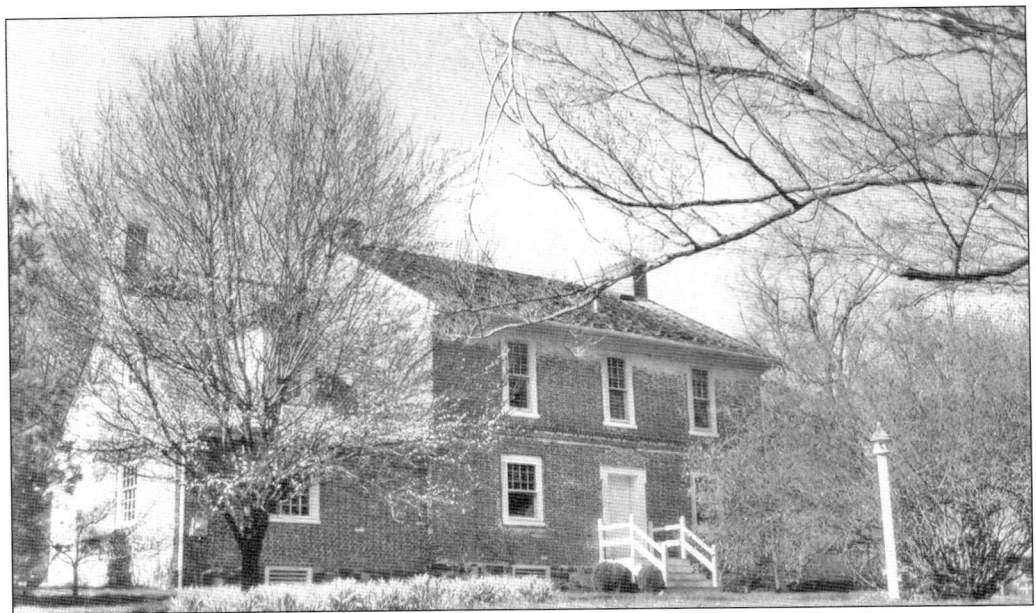

During the American Revolution, Andrew Fisher operated a grist and sawmill just south of Newark and constructed his home just east of the mills. Following his death in 1804, Fisher's sons inherited the property and sold the mills within four years. While the mills were destroyed by fire in 1883, the Fisher home still stands, and the mill property is now a city park. (Courtesy of Richard L. Dayton.)

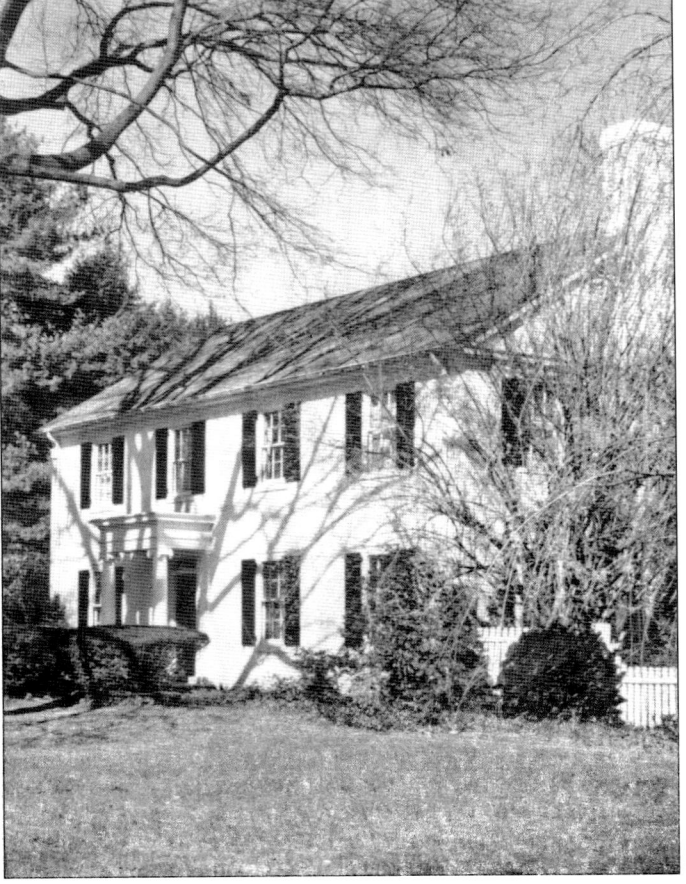

Located at 269 Orchard Road at the corner of Sunset Road, this home was designed and built by Edward William Martin in 1946 or 1947. An architect by training, Martin designed both Newark Senior High School and Brookside Junior High. He also designed the Carpenter Field House and Cannon and Alison Halls for the University of Delaware. (Courtesy of Richard L. Dayton.)

This home was constructed on West Main Street in 1903 by Alfred A. Curtis on land that was originally part of Rathmell Wilson's Oaklands estate. As the Wilson heirs began to subdivide the family farm and property, a large parcel facing West Main Street was purchased by Curtis in 1899. Constructed out of stone transported from nearby Port Deposit, Maryland, the home is one of the largest on Quality Hill. Curtis was the son of Frederick A. Curtis, founder of the Nonantum Paper Mill, which was later renamed the Curtis Paper Mill. Alfred Curtis began working in the family business as superintendent in 1873 and became president in 1911. Once Curtis retired in 1926, the company passed out of the family's possession. The home was purchased by the University of Delaware in 1961 and renovated in 1992. It now serves as the university's English Language Institute. (Courtesy of Richard L. Dayton.)

James Morrow purchased land located on the east side of Newark along Ogletown Road between 1866 and 1875. He built this home in the late 1860s. The home was constructed with a gambrel roof and chimneys on each end. Morrow also opened a driving park on his property in 1877. It was later known as Homewood Trotting Track. In 1911, the house was sold to John F. Richards, who farmed the surrounding land. The property passed through the Richards family and became the property of Anne Richards Stafford, the youngest daughter of John F. Richards. The farm also had a large barn that housed Holstein and Guernsey cows that supplied dairy products to Richards Dairy. The surrounding farmland was used to produce corn and wheat. The home remained in the Richards family until 1983 and is currently slated for demolition. (Courtesy of Richard L. Dayton.)

The Blue Hen Farmhouse dates from the late 18th century. The home and surrounding farm were owned by James and Elizabeth Ray from 1849 until 1862. The property is referred to as Greenwood, owned by W. E. Heisler in D. G. Beer's 1868 *Atlas of the State of Delaware*. Located just north of the city, it was one of a group of farms that surrounded the town. Once an extensive farm, the only structure remaining is the home. The farm's springhouse is clearly visible. It was constructed in the 1840s and demolished in the late 1960s to make way for Stamford Drive. (Courtesy of Richard L. Dayton.)

Ralph Vannoy, pictured on the far right, purchased the Blue Hen Farm in 1945 and in 1948 began construction of the first preservation pond in the state on his property. This photograph captures the beginning of the process. In winter months, the pond would freeze and be used for ice skating. Vannoy also remodeled the home in 1951 and added a two-story wing on the rear of the house. The barn, seen in the background, was destroyed by fire during the 1960s. As the boundaries of Newark expanded, the area around the farm was developed, and much of the existing farmland has been appropriated for use as suburban developments. The area to the south of the home is now a city park. The home remains a private residence and is listed on the National Register of Historic Places. (Courtesy of Richard L. Dayton.)

The Thomas Phillips Mill complex consists of four historic buildings: the Phillips Mill house, a barn, a gristmill, and the Joshua Miller home, located near the gristmill. Situated just west of Newark along Nottingham Road, in recent years, the property has been annexed by the city and is currently being developed for use as townhomes and condominiums. The development plan calls for the preservation and renovation of all the historic buildings, with the Miller home to be divided into two condominiums and the gristmill to house three units. The entire complex is on the National Register of Historic Places. (Courtesy of Richard L. Dayton.)

The Steele House was built near the northwest corner of Delaware and South College Avenues sometime after 1881 for Westley Hart. Rodman Lovett later purchased the home and in 1903 sold the property to Charles Steele, a local butcher. Charles Steele's daughter, Sara, was a teacher in the Christina School District until 1969. The home was purchased by the University of Delaware in 1984. (Courtesy of Richard L. Dayton.)

The Chambers House at 196 South College Avenue was constructed in 1890 by Gilbert Chambers, a local blacksmith. It was during this period that development in Newark began to shift away from Main Street. The home is now the property of the University of Delaware and serves as a visitors center. (Courtesy of Richard L. Dayton.)

The home of John Evans was located on the northwest corner of Main Street and North College Avenue. Constructed at the beginning of the 19th century, the home was purchased by Evans in 1804. Evans used the building as both a family home and a cabinetry shop. Later he operated a general store at the location with the assistance of his son, George Gillespie Evans. From 1870 until 1888, the building served as the home of two presidents of Delaware College. An additional wing was built at the beginning of the 20th century, and in 1912, the home was converted into an inn and restaurant. At one time, it housed a restaurant known as the College Inn and later various other commercial establishments. In 1947, it was purchased by the University of Delaware and is now known as Raub Hall. (Courtesy of Richard L. Dayton.)

In 1840, James Martin purchased 263 acres from Henry Whitely. This purchase also included a stone house constructed in 1806. Martin named his property the Deer Park Farm because of the number of deer that roamed the farm. He and his family vanished from Newark rather abruptly, and in 1862, the farm and mansion were sold at a sheriff's sale. After a series of owners, Justin Pie purchased the property in 1883 and owned it at least until 1893. In 1909, the Improved Order of Red Men acquired the home and 17 acres to be used as a retirement home for its members and their wives. The Red Men's Fraternal Home was closed in 1953 because of a dwindling number of lodge members and residents; the property was sold to the Theta Chi Fraternity and later two other fraternities. (Courtesy of Richard L. Dayton.)

After serving as a fraternity house for almost 20 years, the Red Men's Fraternal Home was purchased by the Newark Center for Creative Learning in 1971. They used the building until 1975, when it was sold to a private owner. After numerous plans for renovation and development were unsuccessful, the home remained vacant for many years. In 1994, the building was sold to Ed Soboleski, who attempted to develop the property but demolished the home shortly after. Following demolition, the property was purchased by the First Church of Christ, Scientist, who erected a new church on the site. (Courtesy of Richard L. Dayton.)

George Gillespie Evans was a prominent Newark resident who was active in community affairs. The son of John and Agnes Evans, George was born in 1815. His father owned a home and general store on Main Street. Like his father before him, Evans served as a trustee of both Newark Academy and Delaware College. Evans not only ran his father's store, of which he eventually gained proprietorship, but also purchased and rented numerous properties in and around Newark. In 1856, he married Mary Jane Black and built this home across Main Street from the Evans store in 1863. They had six children, including son Charles, who like his father and grandfather served as a trustee of Delaware College. Evans's daughter Lena continued to live in the home until her death in 1948. The University of Delaware eventually acquired the home and renovated it in 1994. It is listed on the National Register of Historic Places. (Courtesy of Richard L. Dayton.)

This home at 188 West Main Street was constructed sometime around 1840. The tower and western portion of the home were added 30 years later. The home was once owned by Delaware Clark and his wife. Clark served as postmaster of Newark when the post office was located in the Opera House. (Courtesy of Richard L. Dayton.)

According to the 1900 census, this home at 150 West Main Street was once owned by John Pilling Jr. and his family. Pilling, a coal and lumber dealer, was the son of John Pilling, who with Samuel Wright founded the American Hard Fibre Company on the site of the former Dean Woolen Mills. (Courtesy of Richard L. Dayton.)

Between 1838 and 1840, Samuel Bell purchased 134 acres just west of Newark. Sometime in the late 1840s, he constructed the Bell farmhouse. Bell was a trustee of Delaware College and principal of a female seminary at Linden Hall. In 1855, the farm was sold to Andrew Donnell. The home remained in the Donnell family for almost 30 years and remains a private residence today. (Courtesy of Richard L. Dayton.)

Located at 140 West Main Street, this home was built as a single-family residence sometime in the 1880s. The home was constructed in the Second Empire style and sports a mansard roof. Eventually the home was remodeled and divided into five apartment units. (Courtesy of Richard L. Dayton.)

This house at 196 West Main Street stands on part of what was once Oaklands, the estate of Rathmell Wilson. Ernest and Evelyn Frazer and their family bought the property from John Rambo in 1896. After a period of farming land just west of the city, Frazer operated a general store and a cigar store along Main Street. (Courtesy of Richard L. Dayton.)

As various industries thrived, the population of Newark increased in the late 19th century, and development spread beyond Main Street. Homes such as these were constructed along Cleveland Avenue. In fact, many of these homes were constructed for the working families that came to work in the woolen and paper mills. (Courtesy of Richard L. Dayton.)

As the population of Newark increased, homes were constructed on the streets surrounding Main Street, allowing residents to remain close to the retail and commercial aspects of Newark. These homes are located on New London Avenue, just to the northwest of Main Street, and demonstrate the type of housing to be found along much of New London Avenue. Smaller than the elaborate homes found just one block away on West Main Street, homes on New London Avenue were originally constructed for Newark's less affluent citizens. Many of these homes now serve as rentals for the town's student population. (Courtesy of Richard L. Dayton.)

Homes along Cleveland Avenue west of Chapel Street were originally constructed for the working population of Newark. Single-family detached dwellings and row houses are interspersed along Cleveland Avenue, and many were constructed near the beginning of the 20th century. Often more affluent citizens would construct homes along this street to be used as rental properties. Such was the case of Dr. Walter Steel, who constructed row homes in the 100 block of Cleveland Avenue. Today students have replaced workers as the predominant rental population. Many of the homes along Cleveland Avenue still function as rental properties, while the eastern portion of Cleveland Avenue is home to a multitude of automobile dealerships. (Courtesy of Richard L. Dayton.)

As early as the mid-1800s, Newark's African American community established ties in the area of the intersection of New London and Cleveland Avenues. Census reports indicate that the African American population of Newark was concentrated in this area throughout the 1930s. A number of churches were established, such as St. John's African United Methodist Protestant Church, constructed near the intersection of Cleveland and New London Avenues. The Mount Zion Union American Methodist Episcopal Church was constructed in 1869 on New London Avenue, and in 1916, the Pilgrim Baptist Church was built. Today many of Newark's African American residents continue to live in this area. (Courtesy of Richard L. Dayton.)

Built around 1903, this home at 204 West Main Street was the home of Joseph Wilkins Cooch and his family. A member of the prominent Cooch family, J. Wilkins Cooch married Mary Evarts. The home remains in the Cooch family and is currently owned by Virginia Cooch Hardwick. (Courtesy of Richard L. Dayton.)

J. Wilkins Cooch was born in 1840 at Cooch's Bridge and was educated at both Newark Academy and Delaware College. He served in a variety of civic positions, including as a member of the state senate, a trustee of Newark Academy, a member of Hiram Lodge No. 25 of Newark, and president of Farmers Trust Company. (Courtesy of Special Collections, University of Delaware Library, Newark, Delaware.)

Belmont Hall was built for Thomas Blandy sometime between 1838 and 1844. Blandy was a prominent Newark resident and owned almost 40 acres of farmland around his home. He also invested in the Chesapeake and Dover Canal Company and owned a foundry across from the current Deer Park with his brother, Charles. In addition, Blandy was a trustee of Newark College beginning in 1835 and was appointed treasurer of the board in 1839. Following Blandy's death, the house was sold to Eben Frazer, who owned a drugstore on Main Street and also served as mayor of Newark. Frazer remodeled the home and added the extensive porch. The home was purchased by the University of Delaware in 1950 and at one time served as the home of Pres. John Perkins. It is currently home to the university's Psychological Services Training Center. (Courtesy of Richard L. Dayton.)

Three
UNIVERSITY OF DELAWARE

Pictured from left to right, Katherine Knighton, Barton Mackey, and Marjorie Brown, members of the university's class of 1955, all attended Newark High School. This photograph, taken at the end of their freshman year in 1951, depicts the students gathering on the steps of Memorial Library. (Courtesy of Special Collections, University of Delaware Library, Newark, Delaware.)

Constructed in 1833, the building that is now known as Old College was intended to be home to Newark College. The college opened in May 1834 with 45 students and two faculty members. This was the only building of Newark College until after the Civil War. In 1917, the building was renovated and renamed Old College. (Courtesy of Special Collections, University of Delaware Library, Newark, Delaware.)

Old College was renovated again in 1978 and now houses the Departments of Art History and Art Conservation and the Museum Studies Program and the Winterthur Program, in addition to being home to the University Gallery. This more current view illustrates the many changes made, especially to the surrounding landscape. (Courtesy of Richard L. Dayton.)

This home was originally built by Dr. Joseph Chamberlain in 1809. In addition to his medical practice, Chamberlain was a trustee of Newark College. Following Chamberlain's death, his heirs sold the home to John Watson Evans in 1866. Evans was very active in Newark affairs and served four terms as president of Newark's Board of Town Commissions. He also served as Newark's representative to the State General Assembly, assisted with establishing new town boundaries in 1851, founded Newark's Masonic Lodge, and served as a member of the board of trustees of Delaware College. In 1903, the home was purchased by the university and used for a variety of purposes, including as a fraternity house and library. Until 1970, the building was called Purnell Hall, when it was renamed Alumni Hall. It is listed on the National Register of Historic Places. (Courtesy of Special Collections, University of Delaware Library, Newark, Delaware.)

This view of Elliott Hall and the north Green was taken from Delaware Avenue. Dating back to 1775, it is the oldest building on Main Street. Elliott Hall was originally owned by Alexander McBeath, a local miller, and in 1808, the town's first post office was established in his home. The building was acquired by H. Rodney Sharp and given to Delaware College in 1915. (Courtesy of Richard L. Dayton.)

This image of the north Green was taken prior to the construction of the Brown and Sypherd residence halls. Harter Hall is visible on the right. The arches were constructed with bricks taken from the demolition of the old Delaware House, which also served as the home of the *Newark Post*, at the corner of South College and Delaware Avenues. (Courtesy of Special Collections, University of Delaware Library, Newark, Delaware.)

This view of the Green was taken from the north side of Main Street near Elliott Hall. Memorial Library is in the background. The student population had increased to such a degree that in 1914, the board of trustees hired the architectural firm of Day and Klauder to design and implement a plan for campus expansion. This plan called for a tree-lined campus mall and included a plan for the Women's College. Construction of the first two buildings—Wolf Hall, a science building, and Harter Hall, a dormitory—was completed in 1917. In 1925, Memorial Hall was completed to house the college library. Four residence halls were constructed on the north Green, with classroom and research facilities located on the south Green. The campus plan was not completed until 2002, with the construction of DuPont Hall. (Courtesy of Special Collections, University of Delaware Library, Newark, Delaware.)

The *Delaware Ledger* was established in 1876 and was housed in a building on the corner of Delaware and South College Avenues. This academic procession proceeded down South College Avenue toward Main Street. Winifred Robinson, dean of the Women's College, is eighth from the right. (Courtesy of Special Collections, University of Delaware Library, Newark, Delaware.)

This academic procession included a walk along Main Street. Alumni Hall is visible in the background. Winifred Robinson, dean of the Women's College, leads the procession. Traffic on Main Street at this time was two-way, as noted by the cars parked at the curbsides. (Courtesy of Special Collections, University of Delaware Library, Newark, Delaware.)

This view of a commencement exercise at the University of Delaware in front of Wolf Hall was taken sometime after 1917. Construction of Wolf Hall was completed in that year. As one of the first buildings of what is now the main campus, Wolf Hall served as the home of the College of Agricultural Sciences until 1951. It now houses the Department of Psychology. In the background on the right is a barn belonging to Albert Lewis. The Lewis family owned many acres of farmland stretching from Main Street to Park Place and from Academy Street to South College Avenue. Following the death of Albert Lewis, his son, Edmund, took control of the family farm. After Edmund's death in 1897, portions of the farm were sold, including many acres sold to Delaware College. (Courtesy of Special Collections, University of Delaware Library, Newark, Delaware.)

Mitchell Hall was constructed in 1930 on the Green and named in honor of Samuel Mitchell, who served as president of the university from 1914 until 1920. The building was intended to serve as an auditorium, concert hall, and theater, and it continues to serve the university community in this capacity today. (Courtesy of Sylvia Dale Williamson.)

Built in 1917 and named for Thomas Wolf, professor of chemistry, Wolf Hall was one of the first buildings constructed in response to an increase in the student population at Delaware College. It was renovated in 2003 and currently houses the psychology and biological sciences departments. (Courtesy of Sylvia Dale Williamson.)

Memorial Hall opened for use in 1925 as a library for both Delaware College and the Women's College. The building was also intended to serve as a memorial to World War I casualties from Delaware. In the central rotunda is a *Book of the Dead*, with the name of one casualty on each page. The pages of this book are turned daily. Each year, the city of Newark's Memorial Day parade begins in front of Memorial Hall. As the university community expanded, the need for additional library space was resolved through the expansion of the building. In 1963, the larger Morris Library was constructed a short distance away, and Memorial Hall was renovated for classroom use. Today Memorial Hall is home to the university's Department of English and is also listed on the National Register of Historic Places. (Courtesy of Special Collections, University of Delaware Library, Newark, Delaware.)

These photographs were taken on July 9, 1937, on the south steps of Memorial Library. Much of the building flooded as the result of a violent rainstorm on July 5. The damage to books and documents was extensive because all library materials were housed in the basement stacks. Library employees took advantage of pleasant weather to spread wet books out on the steps of the building to dry and succeeded in salvaging many damaged materials. This incident caused college administrators to reconsider the university's physical priorities and led to the expansion of Memorial Library. (Courtesy of Special Collections, University of Delaware Library, Newark, Delaware.)

Since the opening of Newark College, the college's library had been housed in a various locations. Beginning in Old College, where it remained until 1896, the library then moved to nearby Recitation Hall until 1909. At that time, it was moved to Purnell Hall, where it remained until 1916, when the collection was moved to the former Delaware House on the corner of South College Avenue and Main Street. The expansion of the library's collection soon required that the library move again. Opened in 1925, Memorial Library was constructed in response to a need for more space. The main library collection was housed on the basement level. Following a flood in 1937 that destroyed much of the library's collection, it became obvious that renovations were necessary. This photograph of the east wing reading room was taken sometime after 1940, when the building was remodeled with reading rooms added on each end of the building and additional space to allow for the expansion of the collection. (Courtesy of Special Collections, University of Delaware Library, Newark, Delaware.)

Taken in 1951, this photograph depicts the arches that connect Memorial Hall to Hullihen Hall to the west and Brown Lab to the east. The arches were added in 1940, when Memorial Hall was expanded. Memorial Hall was considered the dividing point between the men's and women's campuses prior to the establishment of coeducation in 1945. Since the founding of the Women's College in 1914, interaction between male and female students had been limited to social events such as dances and other student activities. A small number of coeducation classes were also available in the summer months, when the number of students on campus was small. Many of the faculty of Delaware College also taught classes at the Women's College, particularly in the early years of the institution. Since the introduction of coeducation in 1945, the campus has become fully integrated, including coed residence halls, although some single-sex dormitories remain. (Courtesy of Special Collections, University of Delaware Library, Newark, Delaware.)

This view of the women's campus was taken from the east side of Memorial Library. The Hugh Morris Library was constructed in 1963 in this area to replace Memorial Library. The new library was built in a more functional architectural style and provided students with both ample open stacks and a variety of study areas. (Courtesy of Special Collections, University of Delaware Library, Newark, Delaware.)

Memorial Hall, on the right, was built in 1925 to be used as a library by both Delaware College and the Women's College. The library collection quickly outgrew the building's capacity, and it became clear that a new facility was needed. In 1963, Morris Library, on the left, was constructed to accommodate the growing collection, and it still serves as the main campus library today. (Courtesy of Richard L. Dayton.)

This photograph of the class of 1942 was taken on the steps of Old College and shows one of the last all-male freshman classes at the University of Delaware. An attempt at coeducation at Delaware College was made in 1872, when six women entered the freshman class. The number of women enrolled began to decline in the late 1870s and was a factor in the decision of the board of trustees to abolish coeducation in 1885. In 1914, mounting pressure led to the establishment of Women's College, located approximately a half-mile from Delaware College. Both institutions were renamed the University of Delaware in 1921, but the university did not become coeducational until 1945. Until that time, both colleges were considered separate entities with separate campuses and facilities. Today women and the former Women's College campus are fully integrated into the campus community. (Courtesy of Special Collections, University of Delaware Library, Newark, Delaware.)

Throughout the 1950s, the number of students living on campus increased dramatically. As a result, four new dormitories were constructed. The first of these was H. Rodney Sharp Hall, located along East Delaware Avenue and constructed next to Harter Hall in 1952. Main Street can be seen in the background. H. Rodney Sharp graduated with the class of 1900 and in 1903 took a position with the DuPont Company. Sharp established a close relationship with Pierre S. DuPont, an advocate for educational reform in Delaware. An active alumnus, Sharp initiated a fund-raising campaign and enlisted the financial assistance of Pierre DuPont. Sharp was named chairman to the Board of Trustees Committee on Grounds and Buildings and used his expertise and connections to develop an architectural vision for the campus. His devotion to his alma mater was such that he donated a large portion of his personal fortune to the university. (Courtesy of Special Collections, University of Delaware Library, Newark, Delaware.)

Daniel Kirkwood came to Newark in 1851 after teaching secondary school in Pennsylvania. Hired as a professor of mathematics, he also taught classes in astronomy. Kirkwood served as president of the college from 1854 until 1856 before deciding that his salary did not match the responsibilities required for the position and asking to be relieved of presidential duties. (Courtesy of Special Collections, University of Delaware Library, Newark, Delaware.)

The Centenary Celebration was held in 1934 to commemorate the opening of Newark College. The celebration included three days of lectures, pageants, and activities that attracted faculty, students, townspeople, and alumni. In this photograph, former student and benefactor H. Rodney Sharp (far left) and Pres. Walter Hullihen (second from left) are enjoying the festivities. (Courtesy of Special Collections, University of Delaware Library, Newark, Delaware.)

Constructed in 1940 next to Memorial Hall, Hullihen Hall was originally known as University Hall. Partially funded by H. Fletcher Brown, University Hall was so named because it was intended to be an administration building with classroom facilities available to both colleges. Following the death of Walter Hullihen in 1944, University Hall was officially renamed in his honor in 1952. During Hullihen's tenure of 24 years, the longest of any university president, he accomplished many significant milestones. These include the merging of Delaware College and the Women's College into the University of Delaware, the expansion of the physical campus, the establishment of the Foreign Study Plan and the University of Delaware Press, and the creation of the education and chemical engineering departments. Today Hullihen Hall serves as an administration building and houses the admissions office and the offices of the president, vice presidents, and provost. (Courtesy of Special Collections, University of Delaware Library, Newark, Delaware.)

Brown Hall was constructed as a men's dormitory on the north Green in 1942 and named for H. Fletcher Brown, a university benefactor and member of the board of trustees. Located next to Main Street and Sypherd Hall, it originally was used not only as a residence hall but also for guest lectures, informal student gatherings, and other events. (Courtesy of Sylvia Dale Williamson.)

Evans Hall was built to house the engineering program of the men's college. This photograph depicts one of the many laboratories housed within the building. Evans Hall was named for George Gillespie Evans and his son, Charles, who both served as trustees of the school. Together their service spanned the years 1856 until 1933. (Courtesy of Special Collections, University of Delaware Library, Newark, Delaware.)

John Perkins (left) became the youngest president ever to serve the University of Delaware in 1950 at the age of 36. During his tenure, Perkins significantly increased the university's endowment in addition to expanding graduate programs, raising faculty salaries, and expanding and improving the physical campus. It was during Perkins's tenure that the Morris Library was constructed and the library collection increased to better support the research interests of the university community. He is pictured walking along the Green with Allan Colburn. Colburn was a professor of chemical engineering, assistant to the president, and advisor on research. In 1950, he was appointed to serve as temporary president from April to November. During his brief presidency, he encouraged the creation of a marine biology center, and in 1956, a laboratory in Lewes, Delaware, was established. Colburn later became the first provost in the history of the university. (Courtesy of Special Collections, University of Delaware Library, Newark, Delaware.)

The university's Student Center opened in 1958. Located on Academy Street and later renamed the Perkins Student Center in honor of John Perkins, it was constructed during Perkins's tenure as university president. His presidency was marked by great expansion of the university's physical campus, including the construction of the Morris Library, Alison Hall, DuPont Hall, Cannon Hall, and the Student Center. The Student Center served as a home for many student social and cultural events and included a dining hall, coffee shop, faculty room, barbershop, bank, student offices, and a billiards room. In 1982, an addition was constructed to create space for an expanded bookstore. Eventually the student population increased to such a degree that in 1997, the university constructed an additional student center named the Trabant University Center on the corner of Delaware and South College Avenues. (Courtesy of Special Collections, University of Delaware Library, Newark, Delaware.)

E. NEILL TAYLOR C. MESSICK VOSS BROWN BALDWIN KEPPEL,
 FULTON—MGR PIE, P.F.—CAPT. MANNAKEE—COACH
WINGETT CANN, R.T. 4TH FRANCIS, W.M. A. HAUBER L. ROSSELL, P.F. G. PAPPERMA
 JOSEPHS

Football has a long history at the University of Delaware. In fact, in 1876, football was the second team sport to be organized at Delaware College. After four years of dormancy under college president John Hollis Caldwell, football and other student activities were revived in 1889, and in 1891, Delaware College won the state championship in football. For many years, the team practiced and played on a field located close to the corner of Park Place and South College Avenue. The team did not have an official field until 1913, when Frazer Field was donated as a memorial to Delaware College alum Joseph Frazer by his family. Since that time, efforts toward recruitment and scholarship opportunities have been more pronounced, and the university's football program has expanded and produced many championship teams. (Courtesy of Special Collections, University of Delaware Library, Newark, Delaware.)

The men's gymnasium was constructed in 1906 to support the athletic needs of the Delaware College student body. In 1927, the building was expanded, and a swimming pool was added. At that time, the building was named the Taylor Gymnasium in honor of Alexander Taylor, a student who initiated a building fund to pay for renovations. (Courtesy of Special Collections, University of Delaware Library, Newark, Delaware.)

The men in this photograph stand in front of the entrance to Joe Frazer Field. Dedicated in 1913, the field was donated to the University of Delaware by the family of Joe Frazer, a university alumnus who died at a young age. His family donated funds for the construction of various athletic fields, including a football gridiron and baseball diamond. (Courtesy of Special Collections, University of Delaware Library, Newark, Delaware.)

In order to receive federal support under the Morrill Land-Grant College Act of 1862, all colleges were required to include military instruction. Such was the case at Delaware College, which became a land-grant college in 1867. In 1888, the New Morrill Act assigned an army officer as professor of military science at the college as long as enrollment requirements were met. As a result, all students were required to take three years of military instruction and military drill, a requirement not revoked until 1968. To meet the needs of the department, a gymnasium/drill hall was constructed. Cadet uniforms were made in Newark by the Dean and Pilling woolen mills. This photograph of the Officers Cadet Corps was taken behind Old College in 1897. The newly constructed Recitation Hall is seen on the far left. (Courtesy of Special Collections, University of Delaware Library, Newark, Delaware.)

In 1885, the U.S. Army officially established a military department at the University of Delaware and in 1888, under the New Morrill Act, assigned Lt. George LeRoy Brown to serve as professor of military science. Until 1968, students were required to take courses in military instruction and drill in order for the university to receive federal funding under the act. This requirement was eventually called the Reserve Officers' Training Corps (ROTC), which functioned as an active part of the U.S. military. Since 1968, participation in ROTC has been voluntary, and the university has continuously had student participants. Currently there are both U.S. Army and Air Force ROTC detachments on campus. This photograph was taken in 1959 and depicts members of the University of Delaware U.S. Army ROTC program marching at Joe Frazer Field, located behind Old College and Recitation Hall. (Courtesy of Special Collections, University of Delaware Library, Newark, Delaware.)

Winifred Robinson was born in 1867 and received a doctorate in 1912. In 1913, she was selected to become the first dean of the Women's College in Newark. Under her direction, the Women's College expanded its campus, provided students with a wide array of classes and extracurricular activities, and grew enrollment to approximately 300 students. Robinson retired as dean in 1938. (Courtesy of Special Collections, University of Delaware Library, Newark, Delaware.)

Emalea Pusey Warner encouraged higher education for women and was involved in the foundation of the Women's College. She became the first woman to serve on the board of trustees of the University of Delaware in 1928. Residence Hall of the Women's College was renamed Warner Hall in her honor in 1941. She is pictured here with A. D. Shaw. (Courtesy of Special Collections, University of Delaware Library, Newark, Delaware.)

ROBINSON HALL, UNIVERSITY OF DELAWARE, NEWARK, DELAWARE

Robinson Hall was one of two buildings constructed to be part of the Women's College in 1914. Intended to be used as a classroom and laboratory building, it was originally known as Science Hall. In 1940, it was renamed in honor of Winifred Robinson, who served as the first dean of the Women's College from 1914 until her retirement in 1938. Under her direction, the Women's College thrived; it has since been fully integrated into the University of Delaware. Robinson Hall is still in use today and houses the administration offices of the College of Marine and Earth Studies. (Courtesy of Sylvia Dale Williamson.)

ROBINSON HALL, SIDE VIEW, UNIVERSITY OF DELAWARE, NEWARK, DEL.

In 1914, construction was completed on two buildings that would constitute the Women's College, located approximately a half-mile from Delaware College. Originally known as Residence Hall, Warner Hall was constructed to be used as a dormitory and was renamed in 1940 to honor the work of Emalea Pusey Warner. Warner was from a prominent Wilmington family and was a member of several civic organizations. Her interest in allowing women access to higher education led to her involvement in the founding of the Women's College. Warner used her social and civic connections to organize support for the creation of the school. Once the Women's College became a reality, Warner assisted Dean Winifred Robinson in recruiting students and acquiring funding. In recognition of her work on behalf of the university, in 1928, she was the first woman appointed to the university's board of trustees. (Courtesy of Special Collections, University of Delaware Library, Newark, Delaware.)

Taken from the south side of Memorial Library in November 1937 before the library porch was removed, this photograph shows the location of the Women's College. Memorial Library was considered the dividing point between the men's and women's campuses and was one of the first buildings constructed to serve both the Women's College and the University of Delaware. (Courtesy of Special Collections, University of Delaware Library, Newark, Delaware.)

In response to an increase in enrollment at the Women's College, a residence hall and a dining hall were both constructed in 1926. Kent Hall was intended to serve as a dining hall, and in 1956, it was expanded to include dormitories. It continues to be used for these duel purposes today. (Courtesy of Sylvia Dale Williamson.)

Dr. Walter Hullihen served as president of the University of Delaware from 1920 until 1944. During his tenure, the Women's College and Delaware College were brought together under the name the University of Delaware. Hullihen and his wife are pictured here with women who graduated during Delaware College's brief "experiment" with coeducation from 1872 until 1885. Pictured from left to right are Mrs. Charles W. Reed, Martha Wilson (granddaughter of Rathmell Wilson, former Delaware College president), Emma Blandy, May Javier, Mrs. Walter Hullihen, Laura Mackey, Mrs. Clarence Pool, Dr. Walter Hullihen, Ida Simmons, and Harriette Clark. Many of these women came from prominent Newark families. Harriette Clark was the daughter of Frederick Curtis, who, with his brothers, founded the Curtis Paper Mill, while the Blandy family lived at Belmont Hall on Quality Hill. (Courtesy of Special Collections, University of Delaware Library, Newark, Delaware.)

In honor of the centenary celebration of the founding of Newark College in 1934, May Sharp donated $700 for the construction of entrance gates for the Women's College. Sharp was the sister of H. Rodney Sharp, prominent university benefactor, alum, and member of the board of trustees from 1915 until his death in 1968. Located off South College Avenue, the gates remain today. (Courtesy of Special Collections, University of Delaware Library, Newark, Delaware.)

Enrollment at the Women's College expanded faster than buildings could be constructed. A second residence hall constructed in 1918 failed to solve space constraints. This photograph of Topsy, Turvey, and Boletus Halls was taken around 1942. Although they were intended to be a temporary solution to a much greater need, Topsy, Turvey, and Boletus Halls remained in use for approximately 30 years. (Courtesy of Special Collections, University of Delaware Library, Newark, Delaware.)

This photograph of the University's Women's Aquatic Club was taken in 1952. Members depicted include, from left to right, Mary Lou Pinder, Susan Ferver, Grace Ann Goodrich, Isabel Brown, Ida Mae Ladd, Virginia Wells, Evelyn Klahr, Adele Feldman, Pat Thompson, Barbara Wynn, Eleanor Williams, Dana Lamb, and Alisan Buckley. (Courtesy of Special Collections, University of Delaware Library, Newark, Delaware.)

This image was taken during the 1930s. The University Press Club was one of many student organizations at the university. Pictured from left to right are Elizabeth Adge, Jean Mason, Anne Cheavers, Elizabeth Wills, Marjorie Slider, Margaret James, and Vernona Chalmars. (Courtesy of Special Collections, University of Delaware Library, Newark, Delaware.)

This aerial view of the University of Delaware was taken in December 1940. This view, looking north from Memorial Hall, depicts the tree-lined south Green. Hullihen and Mitchell Halls are visible on the left, while Brown Lab, Evans Hall, and Wolf Hall are visible on the right. In 1914, the board of trustees hired the noted architectural firm of Day and Klauder to create an architectural plan for the campus. This photograph was taken before many of the buildings envisioned were constructed. Only one residence hall, Harter Hall, had been constructed on the north Green. A period of extensive physical growth that marked the presidency of John Perkins furthered the campus plan, but it was not until 2002, with the completion of DuPont Hall, that the campus conceived by Day and Klauder was completed. (Courtesy of Special Collections, University of Delaware Library, Newark, Delaware.)

Four
RESIDENTS AND BUSINESSES

Herman's Quality Meat Shoppe, a family business, was founded in 1967, when Luther and Jeanette Herman purchased McMullen's Meat Market on Main Street across from the Deer Park. A butcher shop had existed on this site for almost a century. The Hermans' son, Lynn, designed and created the sign that still hangs in the store. (Courtesy of the Herman family.)

An increase in business led the Hermans to move the store to a larger location one block north on East Cleveland Avenue at the corner of Wilbur Street. The increased space allowed the Hermans to introduce a larger variety of products. In 1992, the second generation of the family took over the store when Tim and Christine Herman purchased the business. (Courtesy of the Herman family.)

Herman's Quality Meat Shoppe has remained in business for 40 years, and the Herman family has remained committed to supporting the Newark community and often sponsors and participates in community events. Tim Herman purchased the business from his father in 1992 and is pictured in 2006. (Courtesy of the Herman family.)

The Thomas Cooch House was constructed in 1760 on 200 acres. On the far outskirts of Newark, Thomas Cooch erected a grist and sawmill near his home. During the American Revolution, General Washington fought Lord Cornwallis at Cooch's Bridge, and Cornwallis used the Cooch House as his headquarters for a brief period. (Courtesy of Special Collections, University of Delaware Library, Newark, Delaware.)

This home located just south of Newark along Sunset Lake Road, also known as Route 72, and Old Baltimore Pike sits next to the Dayett Mill, a flour mill located near Cooch's Bridge and the Cooch home. This area played a significant role in the American Revolution. (Courtesy of Richard L. Dayton.)

Taken in front of Oaklands, the home of Rathmell Wilson, this photograph features (in the carriage) Eliza Wilson (left) and Anna Hossinger (right). Others in the photograph are unidentified. Rathmell Wilson served as a member of the board of trustees of Delaware College from 1847 until 1888 and was a farmer. Eliza Wilson was Rathmell Wilson's daughter. (Courtesy of Special Collections, University of Delaware Library, Newark, Delaware.)

The Oaklands estate of Rathmell Wilson was also a working farm. On census reports, Wilson listed his occupation as farmer. This photograph shows the working aspects of Wilson's estate. Cattle were raised, as were various crops. The estate eventually passed to Wilson's granddaughters, who subdivided the land and sold off portions. (Courtesy of Special Collections, University of Delaware Library, Newark, Delaware.)

Oaklands, the home of Rathmell Wilson, was built in the first half of the 19th century. Wilson married Martha Meeter, daughter of Samuel Meeter, in the 1830s and built the home shortly after. In addition to the mansion, Oaklands served as a working farm that sold and traded goods with many of Newark's residents. Wilson served the University of Delaware as president from 1859 until 1870 and as a member of their board of trustees until 1888. Following Rathmell Wilson's death, the home passed to Wilson's son, Edward, and later to Edward's three unmarried daughters, known as the Misses Wilson. During their ownership, Oaklands served as a social gathering place for both students and town residents. The sisters offered dance lessons and hosted numerous parties. The home was demolished in 1964 by developer Hugh Gallagher to make way for a suburban development. (Courtesy of Special Collections, University of Delaware Library, Newark, Delaware.)

Helen Elizabeth "Eliza" Wilson was born at Oaklands in 1837 and was the daughter of Rathmell Wilson, former trustee of Delaware College and owner of the Oaklands estate. Her mother was Martha Meeter, the daughter of Samuel Meeter, who had founded a paper mill just to the north of Newark that eventually became the Curtis Paper Mill. Eliza had one sister named Annie and a brother, Edward. Neither she nor her sister married, and they lived the majority of their lives at Oaklands. Like his father before him, Edward served as trustee of Delaware College, and his former home is now part of the university's Department of Agriculture. Like other family members, Eliza was active in Newark's social network and maintained relationships with other prominent Newark women, such as Annie Hossinger. Eliza Wilson died in 1909. (Courtesy of Special Collections, University of Delaware Library, Newark, Delaware.)

Albert G. Lewis was born in 1798 and attended Newark Academy in 1813. Following his father's death, Lewis inherited land in Kent County, Delaware. He later purchased much of the land upon which the University of Delaware now sits and established himself as a gentleman farmer. Lewis maintained accounts with many prominent Newark residents, such as Samuel Wright, E. W. Haines, William Cooch, and Joseph Hossinger. In 1829, he married Catherine Lum, and together they had six children, four of whom survived into adulthood. Early maps and deeds indicate that he owned land from present-day Academy Street westward to South College Avenue and from Main Street southward to East Park Place, including over 100 acres purchased from Thomas Blandy in 1844. As the town population increased and the boundaries expanded, portions of the Lewis farm were appropriated by the city for the construction of roads. Lewis died in 1883. (Courtesy of Special Collections, University of Delaware Library, Newark, Delaware.)

Catherine Lum Lewis was born in 1808 to John Lum and Hester Allman near Summitt Bridge, Delaware. In 1829, she married Albert Lewis, the same year that they built a family home in Newark. Theirs was a marriage of equality, as evidenced by a marriage contract that listed each other as heirs and a list of the personal property that Catherine brought to the marriage. Catherine conducted various real estate transactions with Albert Lewis acting as her agent. Records remain indicating that the Lewis family owned several slaves in addition to having indentured servants. Catherine maintained a number of records that have survived, including a recipe book and a family Bible in which she recorded the births, deaths, and marriages in both her immediate and extended families. Catherine died of cholera in July 1847 at the age of 39. (Courtesy of Special Collections, University of Delaware Library, Newark, Delaware.)

The family home of Albert G. Lewis was built around 1829 and is noted on D. G. Beer's map of 1868. A prominent Newark farming family, four generations of the Lewis family lived in the home, built along what would become Academy Street. It was later purchased by the University of Delaware and demolished. (Courtesy of Special Collections, University of Delaware Library, Newark, Delaware.)

Henrietta A. Lewis was born to Albert G. Lewis and Catherine Lum Lewis in 1833. Henrietta was raised in the Lewis family home on Academy Street. In 1857, she married Aaron Marshall. Later the Marshall family moved to Philadelphia. She is pictured here (seated on the left) with her children. (Courtesy of Special Collections, University of Delaware Library, Newark, Delaware.)

This portrait of Alfred Curtis was taken in 1872. In 1903, he constructed a home on West Main Street that is now on the National Register of Historic Places and houses the university's English Language Institute. The last member of the Curtis family to manage the Curtis Paper Mill, Alfred retired in 1926 and continued to live in Newark until his death. (Courtesy of Special Collections, University of Delaware Library, Newark, Delaware.)

Joseph Hossinger was a prominent Newark citizen. For many years, beginning in approximately 1797, he operated Hossinger's Tavern on the site that is now Klondike Kate's Restaurant. Active in civic affairs, Hossinger had at least four children—James, Joseph, Andrew, and Annie—who were also active in Newark affairs. (Courtesy of Special Collections, University of Delaware Library, Newark, Delaware.)

96

James Hossinger was a prominent Newark farmer who was deeply involved in the community and held several civic positions, including trustee on the board of Delaware College as well as treasurer for the board of trustees of the Academy of Newark; Aetna Hose, Hook, and Ladder Company; and Newark Real Estate Company. He was also president of the National Bank of Newark. (Courtesy of Special Collections, University of Delaware Library, Newark, Delaware.)

Anna Kerr Hossinger was the daughter of Joseph and Charlotte Hossinger and the sister of James Hossinger. Her father, Joseph, operated Hossinger's Tavern as early as 1797 on what is now the corner of Main and Choate Streets. She lived for a number of years as a boarder at the Deer Park Tavern and was active in Newark affairs. (Courtesy of Special Collections, University of Delaware Library, Newark, Delaware.)

Stephen Choate was the son of a Newark shoemaker. According to census records, Choate was born in 1832 and by 1866 was listed as a retail dealer. After many years operating a tobacco shop and newsstand, Choate retired but continued to live on Main Street. In 1885, he also served as the town's postmaster. (Courtesy of Special Collections, University of Delaware Library, Newark, Delaware.)

Egbert Handy was born in 1858. He attended Delaware College and with James Vallandigham Jr. published *Newark Delaware Past and Present* in 1882, one of the few books documenting the history of Newark. Handy also edited the *Delaware Ledger*, a local Newark newspaper, for many years. He died in 1938. (Courtesy of Special Collections, University of Delaware Library, Newark, Delaware.)

George Gillespie Kerr was born in 1835 to Andrew and Hannah Kerr. Census reports indicate that Kerr was a farmer, as was his father, with them both owning property along Elkton Road. Andrew Kerr's home at 812 South College Avenue is listed on the National Register of Historic Places. George Kerr also served as trustee of Newark Academy and Delaware College and as trustee of Newark Presbyterian Church. In addition, he was director of the Casho Machine Company, a local business that manufactured wagon axles and farm equipment such as reapers and mowers. The Casho Machine Company was organized in 1853, when Jacob and George Casho partnered with William Johnson. The company was reorganized many times under various owners and partners but by 1872 had become established under the Casho Machine Company name. (Courtesy of Special Collections, University of Delaware Library, Newark, Delaware.)

Everett Johnson graduated from Delaware College in 1899. He wed Louise Staton in 1902, taught for several years, and in 1909 founded the *Newark Post*, a weekly newspaper. On a large tract of land at the corner of South College Avenue and West Park Place, Johnson constructed both a print shop and the family home. In 1916, he established the Press of Kells to pursue the art of fine printing. In addition to editing and distributing the *Newark Post*, in 1910, Johnson was elected to the state legislature, where he served a two-year term. He was also active in promoting the establishment of the Women's College in Newark. Based on his previous political work, in 1917, Johnson was appointed secretary of state under Gov. John G. Townsend Jr. and served in this position until January 1921. Everett Johnson died in February 1926 after a lifetime of ill health. (Courtesy of Special Collections, University of Delaware Library, Newark, Delaware.)

Taken in August 1925, this photograph of the Press of Kells employees outside of the Press of Kells features owner Everett Johnson (third row, third from right). Plant foreman Harry Cleaves is second from right in the second row. Cleaves built a home not far from the Press of Kells and named the road Kells Avenue. (Courtesy of Special Collections, University of Delaware Library, Newark, Delaware.)

The Press of Kells building was constructed in 1916 at Park Place and South College Avenue by Everett Johnson to house the *Newark Post* and the Press of Kells, a fine printing company founded by Johnson. Following Johnson's death in 1926, his widow, Louise, took control until 1935 when the financial burden became too great. (Courtesy of Special Collections, University of Delaware Library, Newark, Delaware.)

Frank Mayer Jr. is pictured around 1947 gathering eggs at his family's farm off Elkton Road. Mayer is now co-owner of Spicer-Mulliken Funeral Home and has served the Newark community in a variety of ways, including as a member of the board of trustees of the Newark Senior Center and the board of directors of the Independence School. (Courtesy of Frank C. Mayer Jr.)

Spicer-Mulliken Funeral Home had served the Wilmington, New Castle, and Delaware City communities for over 50 years when William Warwick purchased this building at 121 West Park Place. Originally named Newark Funeral Home, the business became known as Warwick Funeral Home and then Spicer-Mulliken and Warwick. Now owned by Harvey Smith Jr. and Frank Mayer Jr., the company continues to operate under the name Spicer-Mulliken. (Courtesy of Frank C. Mayer Jr.)

The Newark Shell Service Station was located at the corner of Delaware Avenue and Chapel Street. Built in the 1950s, Robert Hessey purchased the business in 1980 after leasing for 10 years. This image, taken sometime in the 1960s, depicts the service station before an additional bay was constructed. After 31 years of operation, Hessey's Auto Center was sold to 7-11 in 2001. (Author's collection.)

Delaware Auto Parts is located on East Cleveland Avenue one block north of Main Street and has served the local community and service stations for over 25 years. East Cleveland Avenue has long been home to numerous car dealerships, with a few other businesses interspersed. (Courtesy of Delaware Auto Parts.)

103

Dr. G. Burton Pearson Sr. was born in 1869 and attended Harvard Medical School. In 1900, he married Estelle Cochran of Middletown, Delaware, and in 1905, the couple had a son named G. Burton Pearson Jr. In 1918, Pearson Sr. moved his medical practice from Middletown, Delaware, to Newark. He purchased the Green Mansion at 94 East Main Street to serve as both the family home and his office. The building was later purchased by Dr. Tomas Cox and serves as office space and a dental office. Pearson's son, G. Burton Pearson Jr., lived on Main Street from 1918 until 1941. He attended Princeton University and later became a prominent Delaware lawyer, judge, and banker. Pearson Sr. died in the 1950s and is pictured driving around town sometime in the 1920s. (Courtesy of Special Collections, University of Delaware Library, Newark, Delaware.)

Five

Transportation and Industry

This photograph was taken in 1914 and depicts a new trolley line through Newark. Visible is Hill's Cigar Store and Quick Lunch, probably owned by Leslie Hill, who according to the census of 1910 operated a restaurant on Main Street. Interestingly both the 1900 and 1920 censuses list his occupation as florist. (Courtesy of Special Collections, University of Delaware Library, Newark, Delaware.)

A Portion of the Employees of Joseph Dean & Son's Woolen Mill, Photographed at the Mill at noon hour of March 28th 1882.

The Dean Woolen Mills were established in 1845 by Joseph Dean in a converted gristmill and would eventually become one of the largest employers of Newark residents. During the years of the Civil War, the mills produced woolen goods for the Union army. This photograph was taken during the noon hour on March 28, 1882, and depicts only a portion of the employees of the Joseph Dean and Sons Woolen Mill, including many women and children. A Christmas morning fire destroyed the building in 1886. The site was abandoned and was purchased in 1894 by the American Hard Fibre Company. It became part of the National Vulcanized Fibre Company in 1922 and operated until 1991. The property remained vacant until being renovated for retail, office, and residential space in the late 1990s. (Courtesy of Special Collections, University of Delaware Library, Newark, Delaware.)

The Koelig farm was located off Paper Mill Road near the Curtis Paper Mill. One of the oldest farms in the Newark area, it produced both crops and livestock. The farmhouse was constructed in 1895. In 2000, the City of Newark annexed the house, barn, and outbuildings for use as the city's reservoir, which opened in 2006 after four years of construction. (Courtesy of Richard L. Dayton.)

In 1894, John Pilling and Samuel Wright founded the American Hard Fibre Company on the former site of the Dean Woolen Mills. In 1922, the plant became part of the National Vulcanized Fibre Company. In 1991, the company closed the Newark plant, and the property remained vacant for a decade before the site was renovated and converted into retail, residential, and office space. (Courtesy of Richard L. Dayton.)

The National Vulcanized Fibre plant was located on the site of the former Dean Woolen Mills. In 1894, John Pilling and Samuel Wright organized the American Hard Fibre Company and renovated the Dean mills, which had been destroyed by fire in December 1886. The plant became part of the National Vulcanized Fibre Company in 1922 and produced plastic wood laminates. Vulcanized fibre is typically produced through a chemical process that requires cellulose to be soaked in zinc chloride and then bleached out. This can be a particularly volatile process. The zinc chloride is often removed through the use of water leaching tanks similar to these. A prominent employer of Newark residents, National Vulcanized Fibre closed its Newark plant in 1991. It is unknown when this interior view was taken. (Courtesy of Special Collections, University of Delaware Library, Newark, Delaware.)

CONTINENTAL DIAMOND FIBRE CO. Newark, Delaware

In 1906, J. Pilling Wright founded the Continental Diamond Fibre Company. Wright was the son and grandson of the founders of the competing company, the National Vulcanized Fibre Company. Continental Diamond was a family company; J. Pilling served as president, and his brother Ernest acted as the company's treasurer, while his other brother, Norris, served as vice president. Like the National Vulcanized Fibre Company, the Continental Diamond Fibre Company manufactured laminates of various paper and cloth materials. The company continued to operate under that name until 1952. In that year, the Budd Company took over the property and operated until 1972. The Wrights were not only entrepreneurs but were also deeply involved in the community. J. Pilling was active in the affairs of the University of Delaware and served on its board of trustees for many years, while Norris Wright was director of the Newark Trust Company. (Courtesy of Special Collections, University of Delaware Library, Newark, Delaware.)

The Continental Diamond Fibre Company was located on the corner of Delaware Avenue and South Chapel Street. After the company closed in 1952, the Budd Company took possession of the property until 1972, when they too closed. For the next decade, the facility was used by various businesses but was vacated after 1982. In 1998, the site was sold to a developer and the buildings were razed. (Courtesy of Richard L. Dayton.)

This view of the collapse of the Continental Diamond Fibre Company smokestacks was taken in July 2000. After serving the Newark community for over 65 years, the site had remained vacant for many years. In 2000, the site was razed for the construction of the University Courtyard, an 880-bed apartment complex, and the smokestacks that had been a Newark landmark were demolished. (Courtesy of Robert Cronin.)

In 1837, the Pennsylvania, Wilmington, and Baltimore Railroad established service through Newark, and tracks were laid almost a mile south of town. The arrival of the railroad impacted Newark's growth. South College Avenue was opened to traffic in 1841 and was originally called Depot Street, as it led from the center of town to the train depot. Somewhere between 1845 and 1855, James Martin constructed Linden Hall to the south of the railroad tracks to serve as a summer boardinghouse for travelers. Later a female seminary was opened in Linden Hall with Samuel Bell as principal. This train station was constructed in 1877 and included services previously not available to passengers, such as a telegraph service. Today the tracks serve as part of Amtrak's Northeast Corridor, and the former train station is home to the Newark Historical Society. (Courtesy of Special Collections, University of Delaware Library, Newark, Delaware.)

One of a handful of covered bridges in Delaware, Paper Mill Bridge spanned the White Clay Creek at the Curtis Paper Mill and connected the mill and its employees with the town of Newark. Erected in 1817, the bridge was replaced in 1861 with the bridge in the bottom photograph. The date of construction is visible. In 1949, that bridge was demolished and replaced with the concrete span depicted in the top photograph. Eventually Paper Mill Road was enlarged, and the covered bridge was torn down. The smokestacks of the Curtis Paper Mill are clearly visible. (Courtesy of Special Collections, University of Delaware Library, Newark, Delaware.)

The above view of the Baltimore and Ohio Railroad off Elkton Road was taken in August 1942. The Baltimore and Ohio Railroad laid tracks through Newark in 1886, expanding the service already provided by the Pennsylvania, Wilmington, and Baltimore Railroad, located slightly south of town. The line runs directly through town, crossing Main Street at the junction of Main Street and Elkton and New London Roads. Today the railroad line is part of the CSX system and is used for hauling freight. The white building near the center of the top photograph was once the home of the *Newark Post*. The station is pictured below. (Courtesy of Special Collections, University of Delaware Library, Newark, Delaware.)

By 1851, the town of Newark had nine streets, including Main Street, Ogletown Road, Depot Street, Academy Street (also known as Chinamen's Alley or James Anderson's Lane), New London Avenue, Nottingham Road, Corbit Street, Elkton Road, and Delaware Avenue. All streets remained unlit and unpaved until around 1917. As the town's population increased, development spread outward from the town's center of Main Street. These views of Chapel Street looking south from Delaware Avenue and of Delaware Avenue looking east were probably taken in the early 1920s, before these roads were paved but after the arrival of electricity, as noted by the power lines in each photograph. (Author's collection.)

Around 1906, John Mayer purchased a farm along both sides Elkton Road just south of Newark after years of sharecropping. Cows used to be moved across Elkton Road every day for milking. A working farm through the 1960s, the land was eventually divided among six sons, and the property remains in the Mayer family today. (Courtesy of Frank C. Mayer Jr.)

Farming was once an essential component of Newark's economy, and a large number of Newark residents were farmers. The number of farms in the area has decreased significantly with the arrival of industrialization. In this photograph, hay has been harvested and loaded onto a horse-drawn carriage to be driven into the barn on the Mayer family farm. (Courtesy of Frank C. Mayer Jr.)

Construction on what became the Pomeroy and Newark Railroad was begun by two different railroad companies in 1868 and 1871, with one company building the track from Pomeroy, Pennsylvania, to the Delaware state line and the other from the state line to Delaware City. At the town of Landenberg, Pennsylvania, the Pomeroy and Newark joined with the Wilmington and Western Railroad. Used as both a passenger and a light freight line, the railroad's passenger car was affectionately called the "Pumpsie Doodle." By 1901, the company was searching for ways to reduce costs, and by 1928, the introduction of automobiles decreased the need for such railroad traffic. This photograph of the Pomeroy and Newark Railroad was taken in March 1898 in Newark. The portion of track from the Delaware state line to Newark was abandoned in 1939, while the track from Newark to Delaware City remained in operation until 1982. (Courtesy of Frank C. Mayer Jr.)

Six
Religion and Community

Throughout World War I, numerous organizations were created to promote and support the Allied troops. In Delaware, Liberty Clubs were used as a method of involving local schoolchildren in the war effort. This photograph depicts members of the Newark Liberty Club working garden plots behind Wolf Hall. (Courtesy of Special Collections, University of Delaware Library, Newark, Delaware.)

The city of Newark hosts an annual Memorial Day parade down Main Street featuring active duty, reserve, ROTC, and historic military units, in addition to various other civic organizations. This photograph was taken in 1954. Pilnick's Variety Store can been seen across Main Street. (Courtesy of Special Collections, University of Delaware Library, Newark, Delaware.)

The city sponsors numerous parades down Main Street and other local events, such as Newark Nite and Community Day, each year to encourage community involvement. This photograph of a Memorial Day parade was taken sometime in the 1970s and depicts an unidentified military unit marching eastward on Main Street. (Courtesy of Paul Goodchild.)

Aetna Hose, Hook, and Ladder Company was founded in 1888 in response to the fire that destroyed the nearby Dean Woolen Mills in 1886. Organized with 30 men, within one year, the company had expanded to 57 members. In 1890, the first firehouse was constructed at 26 Academy Street. Until 1913, the company owned numerous hand- and horse-drawn hose carriages and wagons. In that year, they acquired a motorized pumping engine. Eventually the amount of equipment exceeded the space capacity of the existing firehouse, and a committee was appointed to search for a new location. This firehouse was built in 1922 at the corner of Academy Street and Delaware Avenue on land acquired from the trustees of Newark Academy and is still active. In 1963, the company constructed an additional firehouse on Ogletown Road just east of the city. (Courtesy of Special Collections, University of Delaware Library, Newark, Delaware.)

This photograph of Nottingham Road heading east into Newark was taken in February 1938. One of the earliest roads laid out in Newark, Nottingham Road is listed on an 1851 map and leads to the Head of Christiana Church, a Presbyterian church founded in 1708. The Newark Country Club is visible in the foreground. (Courtesy of Special Collections, University of Delaware Library, Newark, Delaware.)

Established in 1921, the Newark Country Club is home to an 18-hole golf course and clubhouse on farmland along Nottingham Road previously owned by Jennie Jex. Since its establishment, the club has maintained a close relationship with both the University of Delaware and the surrounding community. (Courtesy of Special Collections, University of Delaware Library, Newark, Delaware.)

During the first half of the 19th century, Presbyterians in Newark were divided along religious lines. Both sects constructed their own churches, but in 1870, the groups reconciled and began construction of a new church built near the southwest corner of Main Street and South College Avenue. The church was used until 1967, when it was sold to the University of Delaware. (Courtesy of Richard L. Dayton.)

The First Presbyterian Church, located near the corner of Main Street and South College Avenue, was constructed in 1872. In 1967, the building was sold to the University of Delaware. During the building's almost 100 years as a place of worship, many families celebrated significant milestones, such as this wedding of Sylvia Dale and Kenneth Williamson in November 1964. (Courtesy of Sylvia Dale Williamson.)

In 1868, two separate Presbyterian congregations came together and constructed a new church located on Main Street just west of South College Avenue. The main church was finished and dedicated in June 1872. In 1967, the church was purchased by the University of Delaware when the congregation constructed a new facility further west of town. While constructing the Trabant University Center in 1996, the university renovated the church for use as a study area known as Daugherty Hall and incorporated it into the design of the student center. A rear addition to the church was constructed in 1927 to be used as a Sunday school. This portion was demolished to facilitate the construction of the Trabant Center. This image is a view of construction surrounding the church and demonstrates the university's intention to renovate and reuse Newark's historic buildings. (Courtesy of Richard L. Dayton.)

Roman Catholicism was first practiced in Newark in 1850. In 1868, Charles Murphey purchased the old Presbyterian church on the corner of Main and Chapel Streets and donated it to the Catholic diocese. The building was renovated and renamed St. Patrick's and was used until 1880, when the floor collapsed. The building was razed, and the current church was built. The church, renamed St. John the Baptist, was dedicated in 1883 and recognized by the Catholic Church as a parish in 1891. The building was again renovated in 1946. In 1950, the church purchased land northeast of town to build a church, school, and convent. After construction was completed in 1956, the parish was renamed St. John–Holy Angels. In 2002, construction was begun on a larger Holy Angels Church, and the building was dedicated in 2004. (Courtesy of Richard L. Dayton.)

Methodists began meeting in the home of Thomas Meeter at the beginning of the 19th century. Eventually the congregation outgrew Meeter's home, and in 1811, Isaac Tyson began construction of Tyson's Chapel, which served as Newark's first official Methodist church. The chapel was built on the site of what is now Newark Cemetery along Chapel Street. Again the congregation expanded, and a new church site was purchased on Main Street. The new church was dedicated in March 1852. After a fire destroyed the church, the current church was constructed and dedicated in January 1865. Since that time, the church has undergone numerous additions and renovations. (Courtesy of Richard L. Dayton.)

The Head of Christiana Presbyterian Church was built approximately a mile and a half to the west of the town in 1708. It is believed that the name was derived from the fact that the church is located near the head of the Christiana Creek. Originally constructed out of logs, a brick church was built in 1750. It is one of the oldest practicing congregations in Newark today. (Courtesy of Richard L. Dayton.)

This photograph of the choir at the Head of Christiana Presbyterian Church was taken in the 1960s. The use of music is a significant part of worship at this church. Head of Christiana presents an annual Christmas concert in addition to integrating music into their weekly services. (Courtesy of Richard L. Dayton.)

Although Head of Christiana Presbyterian Church had been constructed as early as 1706, the increasing number of Presbyterians required the founding of a separate church, which became known as White Clay Creek Presbyterian. By 1721, a log church was constructed to the east of Newark near the summit of Polly Drummond Hill, but overcrowding forced the construction of a larger church at the present location sometime before 1739. In 1752, yet another church building was constructed on the same site, and in 1785, a stone wall was constructed to surround a portion of the church property. After 103 years of use, the existing church building was replaced in 1855, when the current church was erected. Numerous renovations have been made to the existing building, including the addition of an elevator in 1997. White Clay Creek Presbyterian remains an active and growing church community. (Courtesy of Richard L. Dayton.)

BIBLIOGRAPHY

Gallagher, Hugh F. Jr., Family Papers. Special Collections, University of Delaware Library, Newark, Delaware.

Handy, Egbert G., and James L. Vallandigham Jr. *Newark Delaware Past and Present*. Newark: Delaware Ledger Print, 1882.

Johnson, Everett C., and Louise Staton Papers. Special Collections, University of Delaware Library, Newark, Delaware.

Lewis Family Papers. Special Collections, University of Delaware Library, Newark, Delaware.

Medill, Agnes P., Boys and Girls Liberty Clubs of Delaware Scrapbook. University of Delaware Library, Special Collections.

Munroe, John A. *The University of Delaware: a History*. Newark: University of Delaware Press, 1986.

Newark Planning Department. *Historic Buildings of Newark, Delaware*. Newark: Newark Planning Department, 1983.

Owen, James B. *Historic Newark Delaware: a Guide to the Vernon Good Montage of Newark*. Newark: Newark Historical Society, 1983.

Pearson, G. Burton Jr., Papers. Special Collections, University of Delaware Library, Newark, Delaware.

Pieratt, Asa, Photographs of Delaware. Special Collections, University of Delaware Library, Newark, Delaware.

Powell Family Papers. Special Collections, University of Delaware Library, Newark, Delaware.

Smith, Adele, Scrapbook. Special Collections, University of Delaware Library, Newark, Delaware.

University of Delaware Photograph Collection. Special Collections, University of Delaware Library, Newark, Delaware.

University of Delaware Postcard Collection. Special Collections, University of Delaware Library, Newark, Delaware.

Wilson Family Papers. Newark: Special Collections, University of Delaware Library, Newark, Delaware.

Across America, People are Discovering Something Wonderful. *Their Heritage.*

Arcadia Publishing is the leading local history publisher in the United States. With more than 3,000 titles in print and hundreds of new titles released every year, Arcadia has extensive specialized experience chronicling the history of communities and celebrating America's hidden stories, bringing to life the people, places, and events from the past. To discover the history of other communities across the nation, please visit:

www.arcadiapublishing.com

Customized search tools allow you to find regional history books about the town where you grew up, the cities where your friends and family live, the town where your parents met, or even that retirement spot you've been dreaming about.